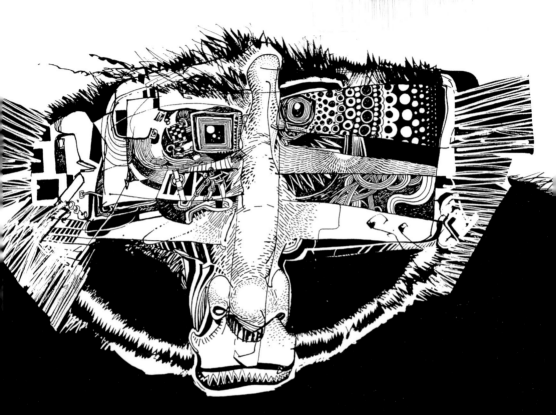

BROADCAST
The TV Doodles of Henry Flint

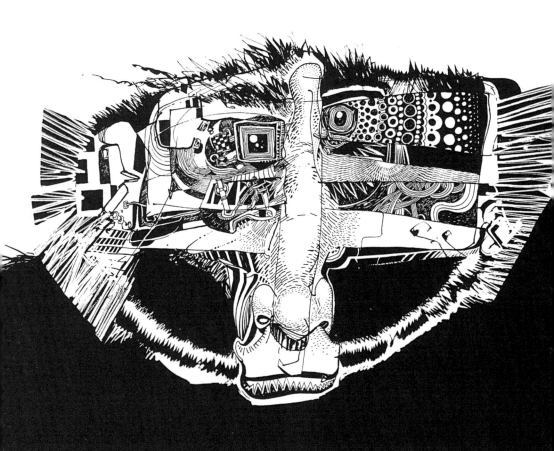

ISBN: 978-1-905692-58-3

BROADCAST
The TV Doodles of Henry Flint

Text by
Cy Dethan

Design by
Ian Sharman

For Markosia Enterprises Ltd

Harry Markos
Publisher & Managing partner

Huw-J
Art Director

Ian Sharman
GM Jordan
Andy Briggs
Group Editors

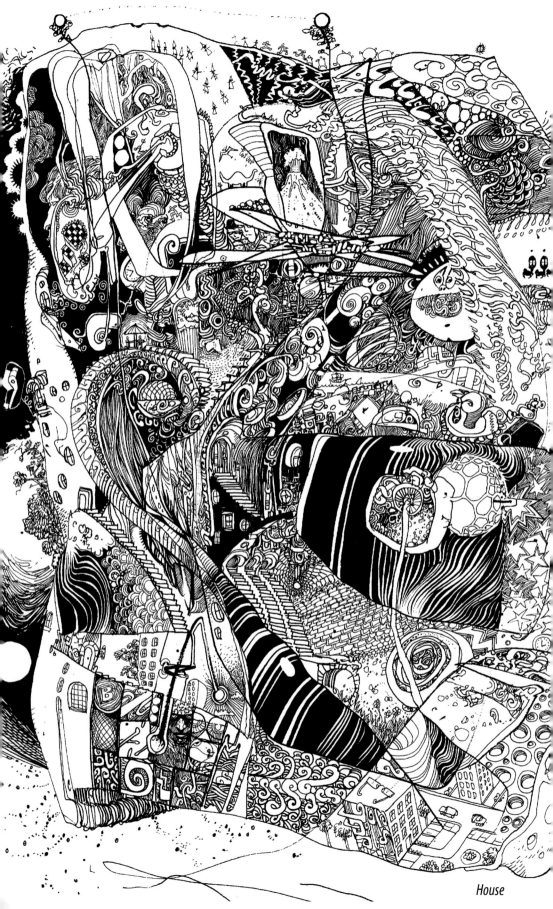

House

Foreword
by Al Ewing

When I was younger, I doodled. A lot.

I had a short attention span, and concentration was difficult, unless I was concentrating on something I liked, which didn't include school. So I'd doodle in the margins of the paper, on the covers of exercise books, on my pencil case, which became a smeary mass of ink. We were given rough books, grey-covered books filled with blank paper - I have no idea what for. Working out maths? First drafts of essays? Handwriting practice? What were they thinking?

Whatever. I filled up the whole thing in about a week, blagged another from an understanding teacher, filled that up even faster. Races between crudely drawn bubble-cars on looping tracks. The adventures of a super-powered worm named, shockingly, Super Worm - adventures which contained no speech bubbles and were therefore impossible for anyone else to follow. Jim Woodring I wasn't. Oh, and in a burst of pre-teen rebellion, I drew a double-spread of firemen putting out fires with sprays of urine from their immense willies, although thankfully no teachers could make that one out either. Tom Of Finland I also wasn't.

I kept doodling right up until my A-levels - essentially as long as learning relied on ink and paper. I even managed to ease the chronic bullying for a short while by putting out single-page comics and handing them around the class - featuring unlicensed adventures of Judge Dredd, since you ask. He was a regular feature of the margins as well, along with Two-Face, Jonah Hex, and Bruce Banner changing into the Incredible Hulk. And endless space battles between fleets of triangular ships, firing ink lasers across the white void.

So how did this terrible disease begin?

My father was a scientist working in a research laboratory. He'd bring back great reams of used computer paper, one side filled with printed calculations and junk data, the other blank, and I would use the blank side to draw on. This was scrap destined for bins, and nobody minded had taking it away, so we had enough to last for years, even after he changed jobs. When I was very young, paper had only one side, and was free. I could use as much as I wanted, for whatever I wanted.

I'd get lost in it, for hours at a time. The conscious mind drops away, the subconscious takes over, and the pen does what it wants. Sometimes, there was a particular goal in mind, but other times I'd just let what came out come out.

Just the ink, and the page, and the doodle.

That's what doodling is: a direct line to the bottom of the brain, letting the conscious mind lapse, listening to music - or the television - while the hand lets the subconscious mind flow out onto the page. And there's no telling what you'll get - geometric shapes, op-art patterns, acid-scarred Harvey Dent, epic battles across imaginary stars… it all depends what tools you have, and what's lying down there in the unseen part of your head, readying itself to crawl out of its cave and onto the paper.

I promised Henry I wouldn't mention him much in this introduction, and I've attempted to make myself the subject as much as possible, but… it's not my book. These are his doodles. This is his head.

I don't know about you, but I'm looking forward to the trip.

Introduction

The mind of Henry Flint is a galaxy of beautiful atrocities – a nightmare factory where the bestial becomes benign, the mundane magical. Henry Flint is at once a full-service doodling savant and a one-man alien zoo, and this book is an attempt to chart a single, crooked leg of the artistic journey he takes daily. Since 1992, that journey has led Henry through more than fifty stories, from the mainstream powerhouses of Marvel and D.C. to the absurdist intricacy of his 2000AD pieces. His total command of abject chaos has shown him to be a master of the complex discipline of comic narration, where strict planning constrains the anarchy and tight control refines the artwork to a point where each line and stroke serves a distinct, definable purpose.

That's not what this book is about.

This is a book about how Henry Flint blows off steam. This is Henry Flint unplugged, off the leash, out of control. The collection you'll find here represents his playground - the safety valve on his blood pressure where ideas strike sparks from one another and mistakes cannot exist because everything is permitted. Welcome to the best of the bestiary.

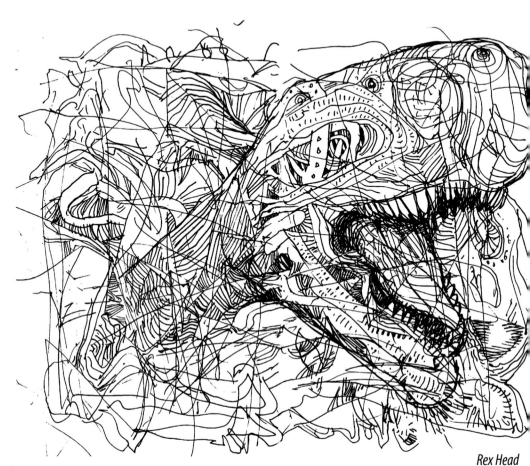

Rex Head

Chapter One
Tuning In

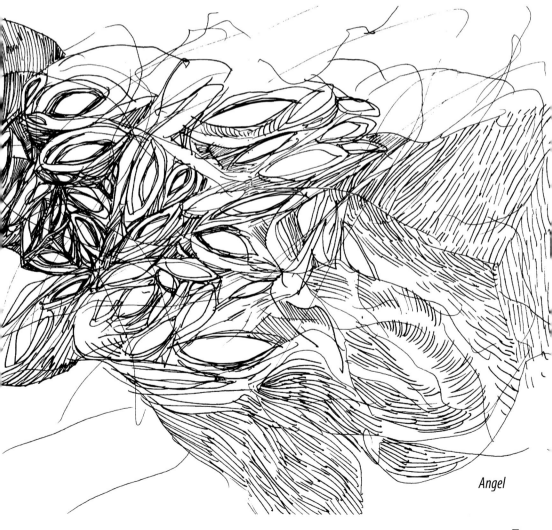

Angel

Henry describes the work in this collection as "TV doodles" – created for their own sake to explore the subconscious territory between brain and hand. He draws a distinction between these pieces and his formal, professional art in that the end result is not strictly the aim of the exercise. The process itself is as important as the product.

While the goal of this collection is to inspire and encourage experimentation, it is closer in structure to a cryptic treasure map than a conventional instructional course - full of riddles and obfuscated symbols. It contains work drawn from a four-year period of unrestrained creative frenzy between 2006 and 2010, initially triggered by a family trip to a Butlins holiday camp. Virtually all the pieces on display are unpaid, non-commission works created specifically for personal amusement and relaxation – a factor that Henry considers critical.

The central thought experiment underlying the palpable, infectious insanity of these doodles stems from the sheer quantity of television required to survive the Butlins experience. Wondering what else he might be doing with his time, Henry decided to draw something totally unplanned whenever he sat down to watch TV. Pencils were thrown out in favour of unrepentantly black pens, while "mistakes" were encouraged and developed in radical new directions.

Using the TV to divert his conscious attention away from his drawing hand, Henry explains, allowed the art to take on a life of its own. Recognisable shapes began to emerge as the doodles developed, moment by moment, with little or no deliberate direction from the artist. Henry describes the evolution of the TV Doodle as follows:

On a trip to Butlins, a few years back now, I took an A3 pad with me to draw someone a picture. He said to draw 'anything you want'. I took him at his word and started a random doodle. The doodle started to centre around a point and the point quickly became an eye. The doodle around the eye became a big head. I gave the head a body riding a bike down a cliff top towards the

sea. I finished off by blacking out the sky to give the picture some balance and adding little people running away from what was now the **Bike Giant** *(see p.12).*

The second picture looked like an alien paisley pattern. I called this one **Butlins** *(see p.13). If that's what the picture wanted to be that was fine with me. The third and fourth attempts fell flat, so I told myself that the third picture wanted to fail and the fourth wanted to show me how the fifth was going to start. Soon, all these games were happening, where images were being created from a blank starting point.*

The fundamental DNA of a TV Doodle is an unapologetically random entity Henry refers to as a "squiggle". Massed squiggles are drawn in ink, and then examined from a variety of angles to see what shapes, faces or figures suggest themselves. Possibilities are explored, discarded or expanded until a natural end point is reached.

That, in essence, is the Henry Flint TV Doodle - anarchy pulsing from a felt tip pen.

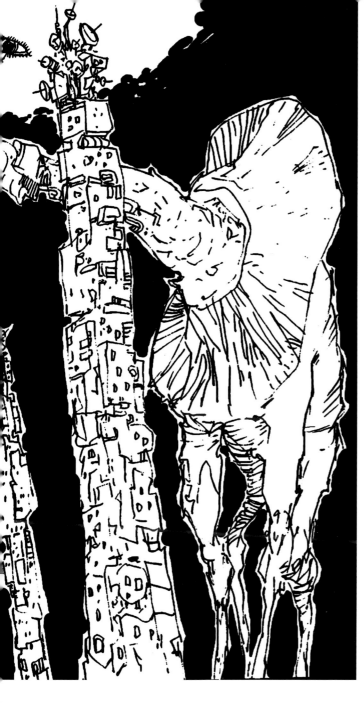

left: A Closer Look At The Problem
below: The Long Bridge

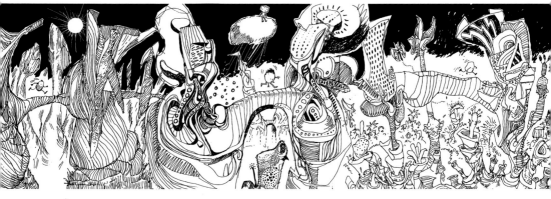

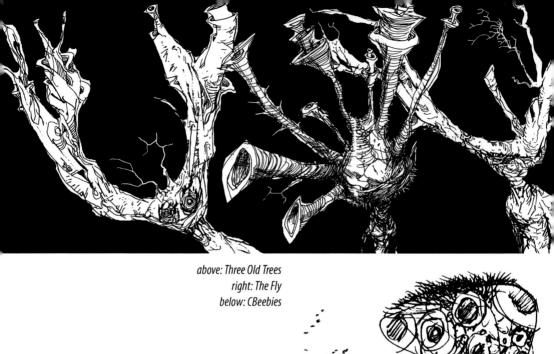

above: Three Old Trees
right: The Fly
below: CBeebies

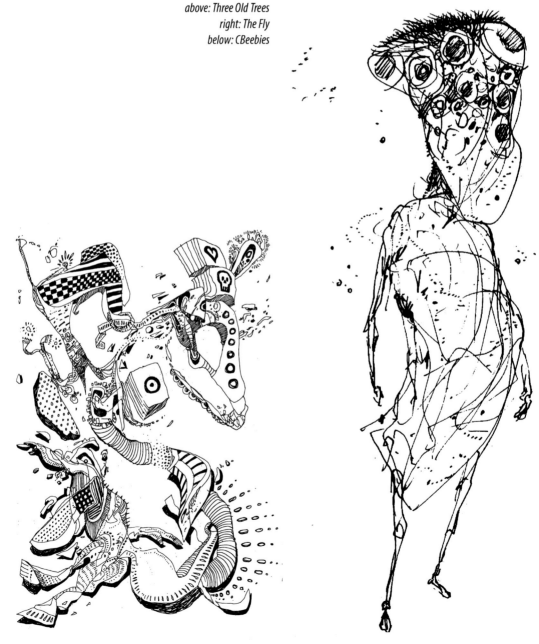

Chapter Two
The First Nine Doodles

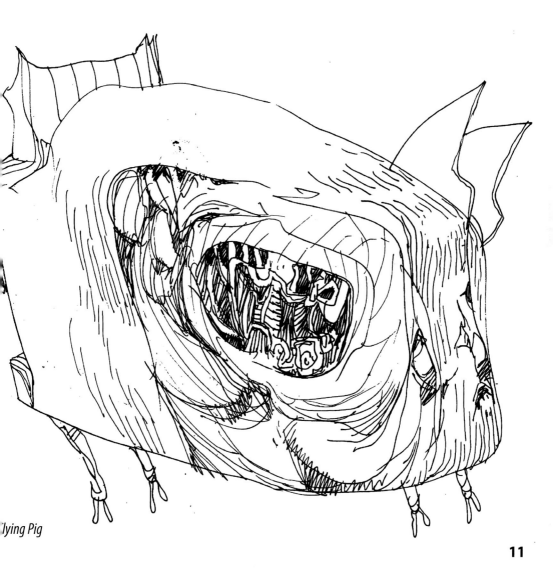

Flying Pig

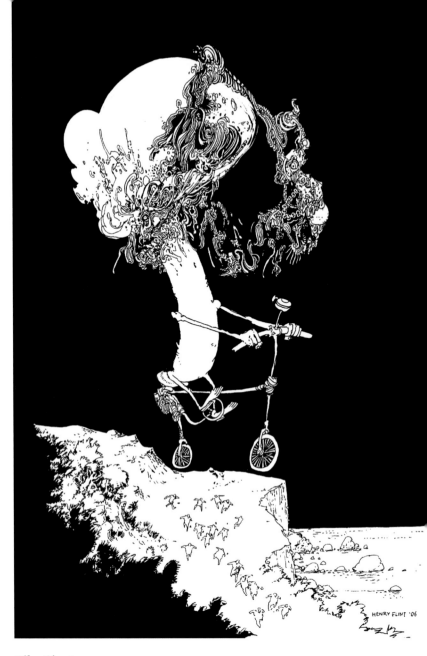

HENRY FLINT '06

Bike Giant

Bike Giant is the doodle that started it all. Henry had been asked to contribu
some art to an online charity auction. No guidance as to style or subject
matter was given and so, while relaxing on holiday with an hour to spare and
a documentary about Channel swimmers on the television, his subconscious
produced this strangely touching image of a monster at play.

Many of the principles of TV Doodling have their roots in this disturbing,
disarming image. Working entirely in ink and discarding conventional figure-
and heroic poses, a crazed and random start revealed something resembling
eye glaring out of the page. Following the logic of the evolving image, the lir
work around this eye developed into a bloated, mushroom-like head. The sta
like body grew naturally in turn, inexplicably bringing with it an absurdly flin
bicycle. Balance and scale came in the form of heavily-inked sky and fleeing
humans and a whimsical monstrosity was born.

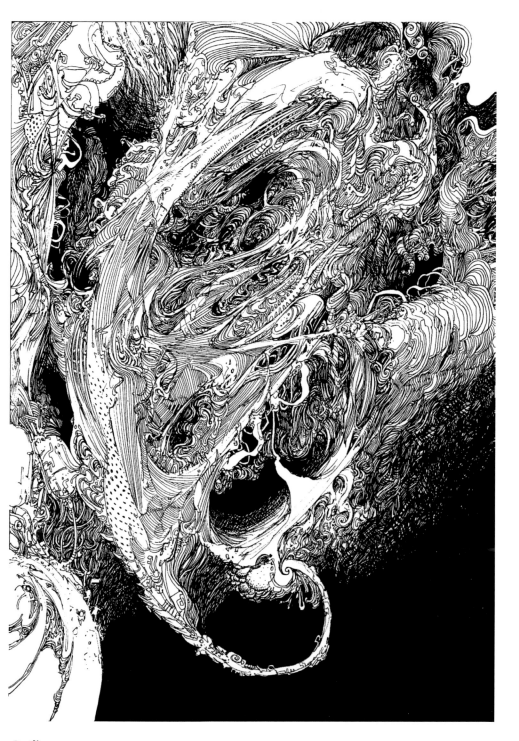

Butlins

Henry created the tempest of surreal energy entitled Butlins on the same night as Bike Giant, through the liberal application of ink to page and wine to artist. He recalls that the programme running on the television concerned the so-called "Curse of Superman" – detailing the various, periodically fatal, misfortunes of people involved in portraying the iconic character or adapting his adventures to other media.

Henry describes the fleshy, sinuous result as a "giant, alien paisley pattern". Again, tiny figures at the bottom provide a sense of nightmarish scale to the piece.

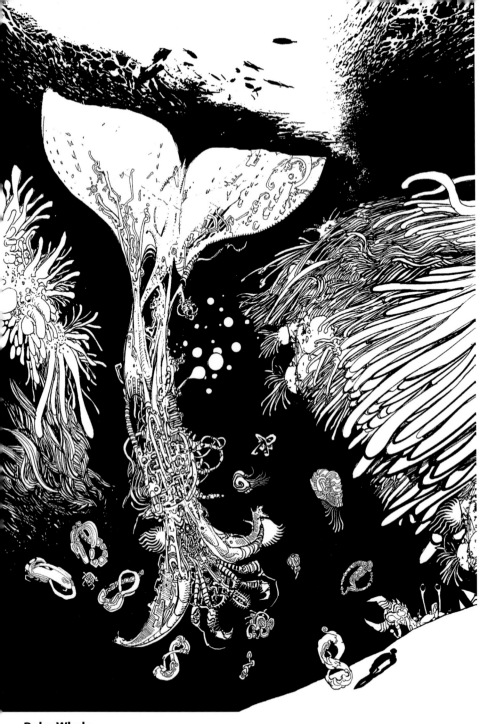

Robo Whale

The night after producing **Bike Giant** and **Butlins**, the graceful monstrosity of **Robo Whale** bled fluidly from Henry's mind and pen. A second "paisley" doodle had, in his estimation, deliberately failed to take form as a means of teaching him something about this new approach to art, and so he decided to explore in a less abstract direction.

The whale and emerging crab represent the top ranks of a food chain in this image. The smaller creatures, with their "figure-eight" or "infinity" designs mirror elements of the processes that produce these images – lesser elements becoming absorbed into larger designs.

It Dropped Out of the Sky to Eat the Rabbit

Taking inspiration from a previous, aborted doodle, Henry dismembered it, rearranged its component parts and produced this Frankensteinean study in sudden, arbitrary and utterly inescapable death. The reassembled doodle struck Henry as a monster hurling itself down from the clouds, predatory mouth agape. A cute, understandably startled bunny provided context to the moment.

As a product of the Watership Down generation, Henry understands that nothing expresses the fragility of life more eloquently than something furry in peril.

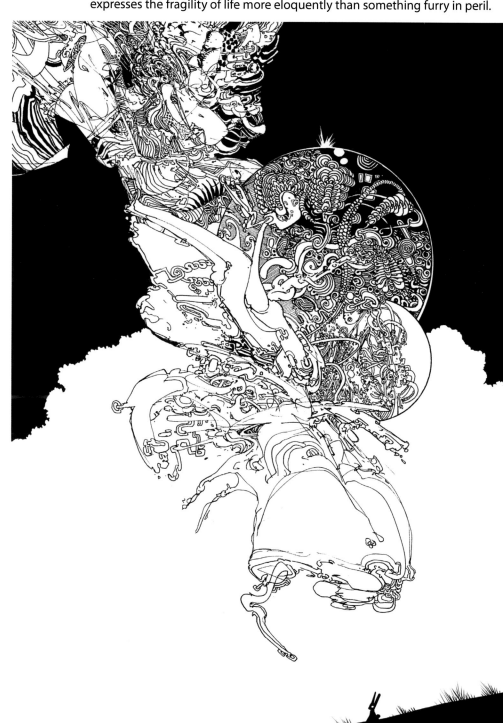

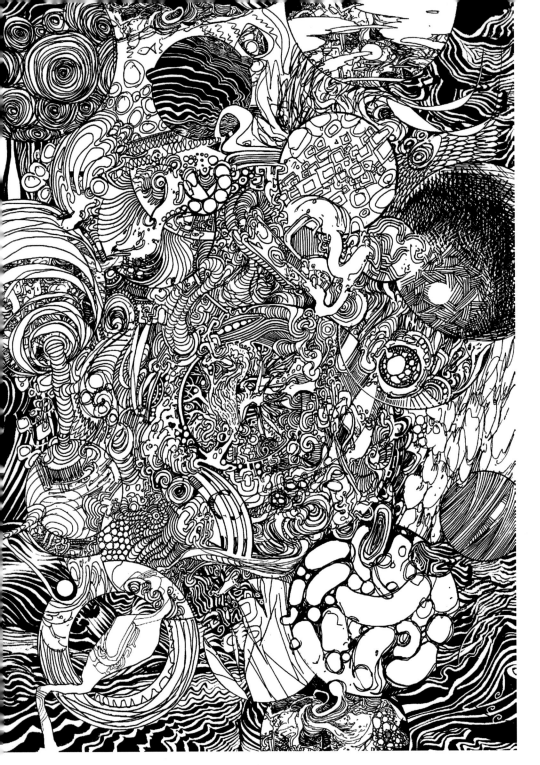

Planets

In kick-starting this doodle, Henry drew several circles with a pair of compasses then subjected himself to a concentrated blast of kids' TV channel, Cbeebies. Picture him as Bill Bixby strapped into the gamma chair in the opening credits of The Incredible Hulk series and you'll start to get the picture.

The results, and the dire warning they represent against the mind-altering properties of children's programming, speak for themselves.

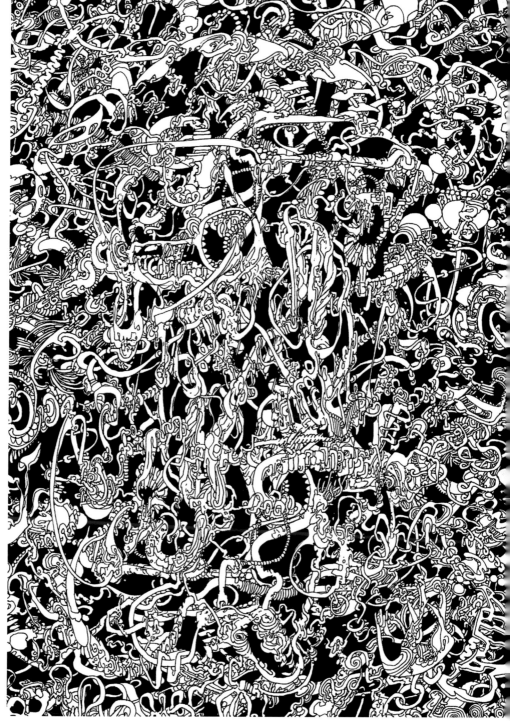

Mess

Henry considers this image to have breached the doodling code somewhat, through underhanded electronic intervention. Feeling the need to, in his own words, "mess about with Photoshop," he pasted an inverted duplicate image over the original. Using the Magic Wand tool, he then selected all the white gaps and pressed "cut" to reveal the original drawing underneath. The layers were then flattened and the white gaps painted black. Close examination of the result, Henry claims, reveals repeating patterns in opposite corners.

Despite the digital meddling, Henry is still comfortable that the image lives up to its title.

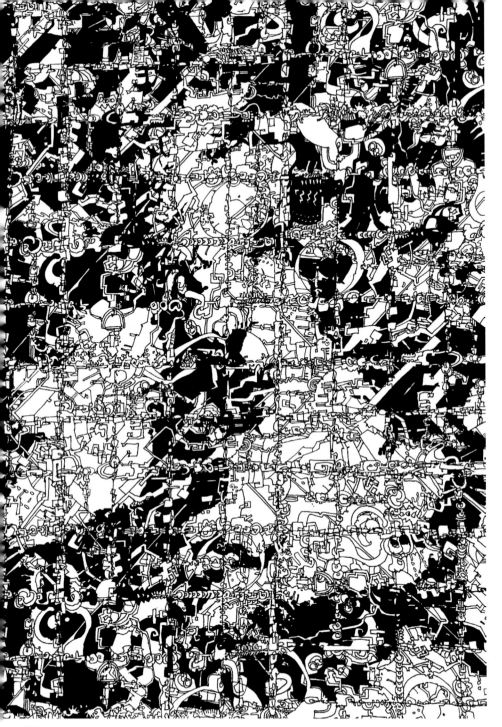

UK

Henry supplies an anecdote to accompany this doodle that, while completely failing to explain how such a drawing is possible to even conceive (let alone wrestle into fruition), at least offers some insight into the circumstances that inspired it.

Having caught the wrong train from Exeter to Taunton, Henry needed to arrange a transaction with his landlady over a mobile phone connection. Trapped on a train bound for Reading with his daughter, Rosalie (then two or three years old), Henry doodled a square grid while making the financial arrangements. On returning home, further experimentation merged the grid with a map of the United Kingdom.

y includes this drawing as an example of doodling "too hard". Having laid down the opening
gles, he attempted to find recognisable shapes within the developing image, rotating the page
entify new perspectives. After fighting the image too intently and too long without satisfaction, he
d on the orientation seen here, deciding that the best interpretation was of a masked face seen in
e.

astonishingly complex and characteristically full of stark contrasts, the doodle's impact remains
tisfactorily vague in Henry's own estimation.
escribes it in terms of a noble,
rtant failure - "lost, confused
bitty."

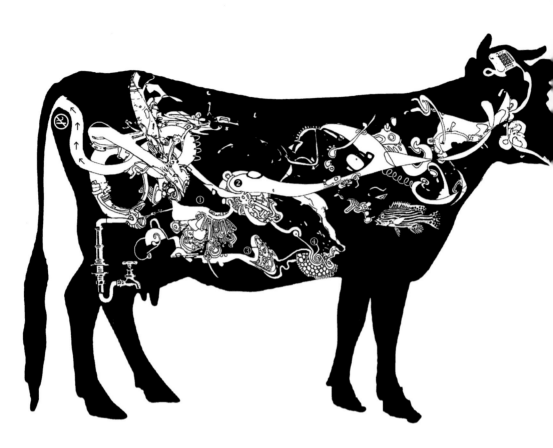

After the exploratory adventure of M
Henry wanted to turn his hand to some
more down-to-earth and readily identif
After due consideration, he discovered tha
humble cow was, scientifically speaking
most trustworthy and "real" thing imagir
He opted for a side elevation, cross-sect
view reminiscent of both a butcher's dia
and an anatomy (

For a while, Henry considered a ser
animal doodles in this style for compil
into a book entitled "Anatomy fc
Bewildered". Unfortunately, the ide
aborted when Henry's next image (a chi
proved simply too weird to release int
wild and had to be humanely destr

Chapter Three
The Follies of Henry Flint

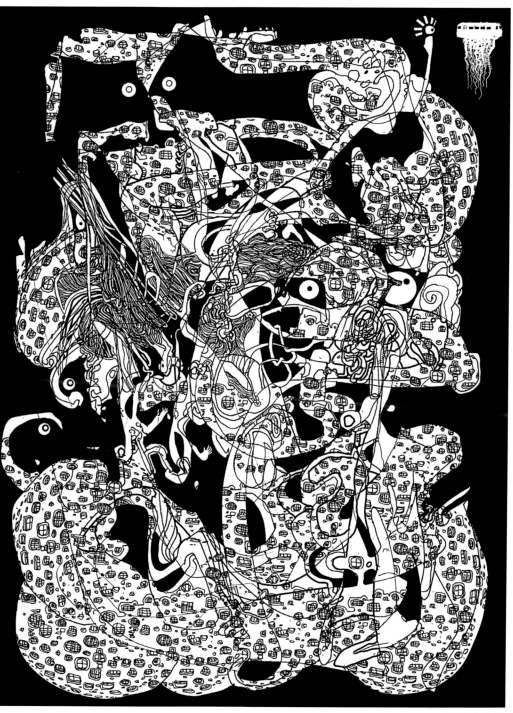

Bus Jellyfish

Henry Flint currently resides in what his estate agent was legally required to describe to him as a "murder house". A serial renter of properties, Henry is easily bored without a change of scenery. Consequently, he has lived at twelve separate addresses around the UK over the last twenty years and the concept of owning his own home (with the accompanying need to care about interest rates, mortgage repayments, maintenance and insurance) holds little appeal for him.

Of course, his attitude makes perfect sense when you consider the type of home Henry thinks of as a suitable purchase, as evidenced in this selection.

At a certain point in the development of Henry's "TV Doodling" process, he noticed various structures edging their way into the designs – some so vividly realised that they brought with them fantasies of owning warped and architecturally improbable castles of his own. Council interference and building regulations were obvious obstacles in realising these follies, but the problem was quickly solved (at least on a conceptual level) by Henry's idea of bristling his fantasy homes with artillery.

Sadly, that solution raised more practical and moral questions than it answered (although it served Hunter S. Thompson well enough for a time) and so Henry made his peace with the property market and remains a confirmed renter to this day.

The murder house has so far utterly failed to manifest any vengeful spirits. Still, it knocked the rent down a bit...

Sky Mous
Gnome World, an idyllic and well populate
fever-dream of Escher-like proportions,
under attack. Seven trolls race across th
entrance bridge in an ill-conceived, fantastic
invasion. The legendary superhero, Sky Mous
floats to the rescue in this delightful slice
utter lunac

Square Ey
Square Eyes started out as a "normal" doodl
following the general anti-process outline
in this book. At some point, Henry decide
that the piece was too generic and so adde
shadow relief for a more solid effec

The Deer and the Lighthous
Henry explains this tangled, intricate image
terms of a short narrative piece. Racing hom
in his car, a lighthouse keeper unexpected
strikes a deer. Delayed by the incident, he on
narrowly makes it back in time to illumina
the beacon and prevent an approaching bo
from dashing itself against the rock

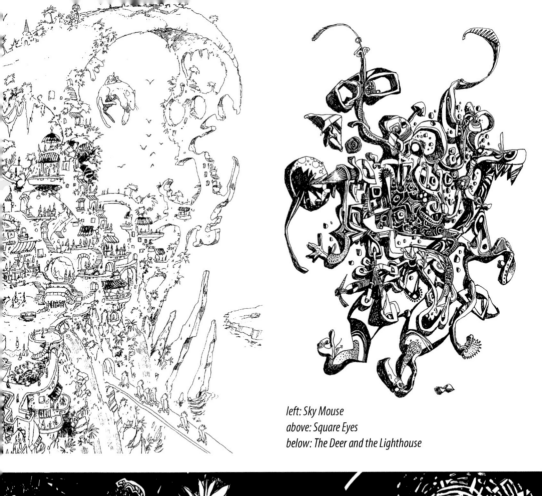

left: Sky Mouse
above: Square Eyes
below: The Deer and the Lighthouse

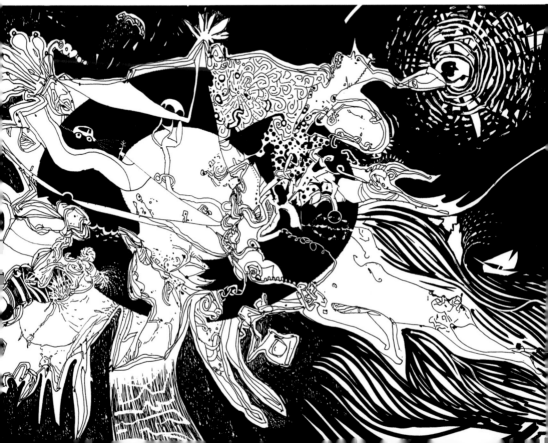

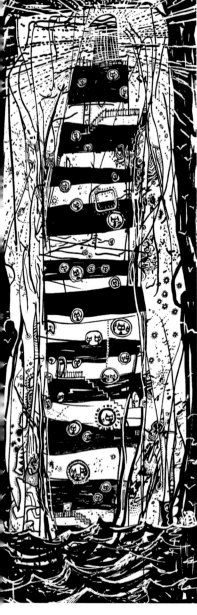
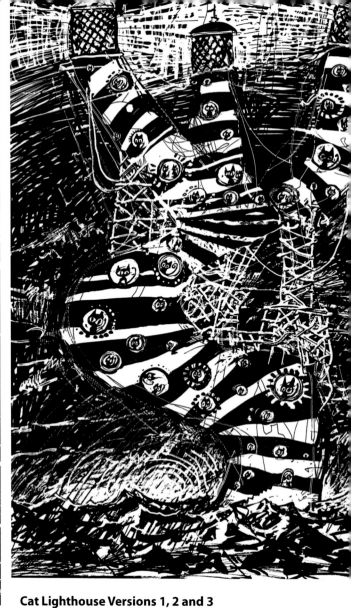
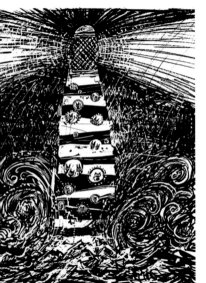

Cat Lighthouse Versions 1, 2 and 3

Picture this: the entire world is flooded and tempestuous. You are the last human being alive. You're in a rowing boat, and there is nowhere to land. The only refuge within reach is a series of lighthouses occupied (and apparently staffed) entirely by cats. You are severely allergic to cats, and you suspect that they know this.

What do you do?

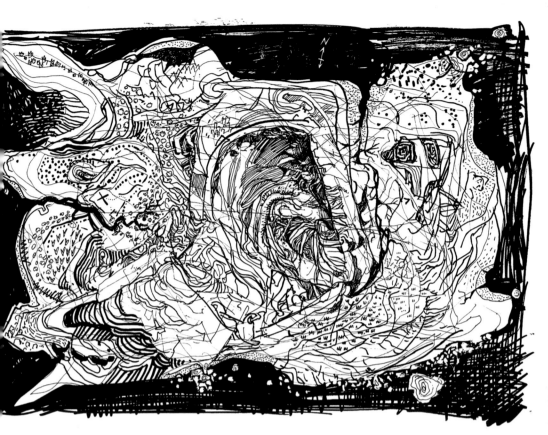

Treasure Map

This image started life as a totally random doodle. Part-way through its development, it took a determined left turn and veered off into Treasure Island territory. Trees sprouted, lagoons and salt marshes formed, landslides manifested and an enormous volcano burst up at the centre.

Looking back at this doodle, Henry occasionally finds himself speculating on the best camping sites should he ever find himself marooned here.

Pile City

Henry's loathing for the property market, rendered in doodle form. He considers it self-explanatory.

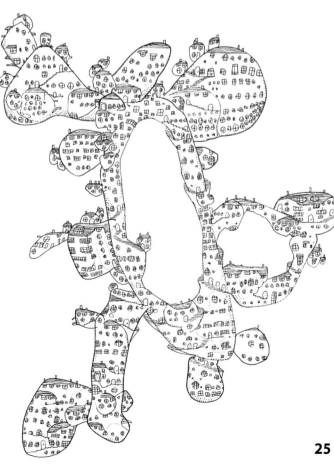

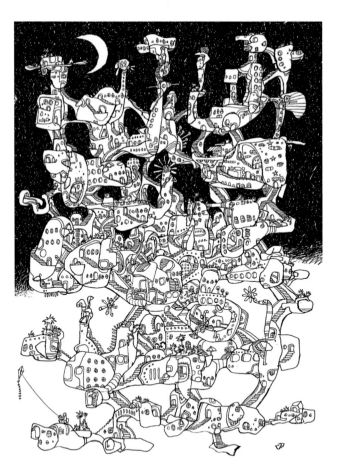

Kite Flying

A glimpse back at Henry's early days as an architectural fantasist. A simple dream, doomed to be ground between the wheels of planning permission refusal and budgetary/scientific constraints.

BBC News 24

During a brief period when Henry entertained the idea of actually *purchasing* property, this doodle began innocently enough from the bottom of the page upward.

Unfortunately, at about the mid-way point, a news item about soaring house prices came on and Henry's drawing hand quickly lost its temper in a lurching, argumentative scribble. Restoring calm, Henry completed the doodle by populating the errant section of landscape with additional, precariously arranged houses.

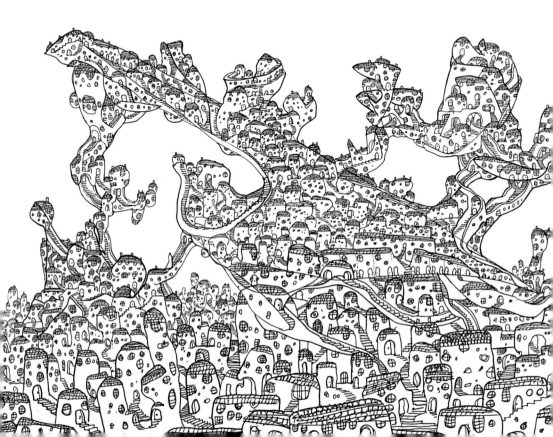

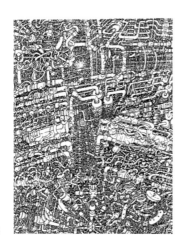

Old Pipes

Pipes

Henry is a big fan of pipes. Maze-like in its complexity, this doodle was created specifically to work into the background of a Shakara comic strip he was drawing for British science-fiction anthology, 2000AD.

Hall of Mirrors

The almost endlessly self-referential and flamboyantly impossible migraine-in-a-bottle that Henry refers to as Hall of Mirrors strains any definition that one might attempt to apply to it. Questioned on the significance and creation of what is, on the face of it, clearly a desperate cry for help, Henry explains only that it involved "drawing loads of random lines with a ruler."

27

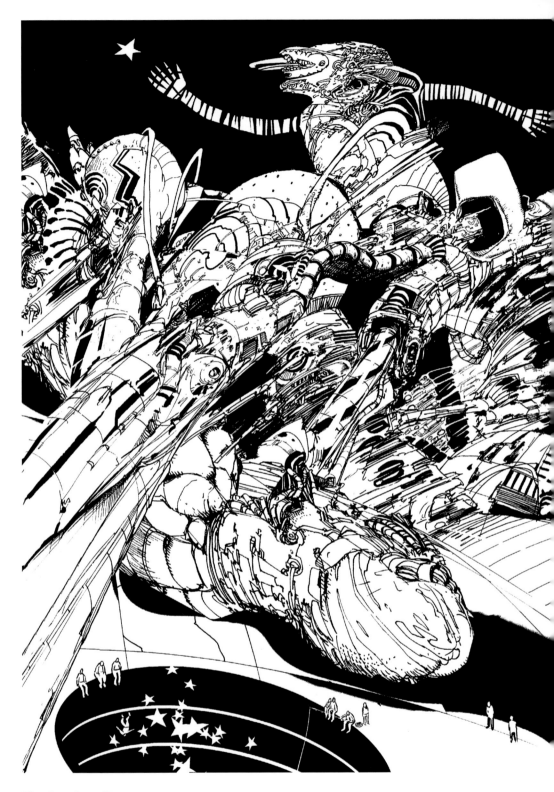

The Star Guardian

Another image that Henry considers to be relatively self-explanatory, again with a narrative feel to it. The Star Guardian, its form rising up from an intense and intricate city-like structure, catches stars that have drifted from the Gravity Hole and returns them to their rightful places. Apparently oblivious to the obvious peril they face, the locals gather calmly around the singularity to chat and fish. Henry once used this image as a Christmas card for friends and family.

Chapter Four
Creatures

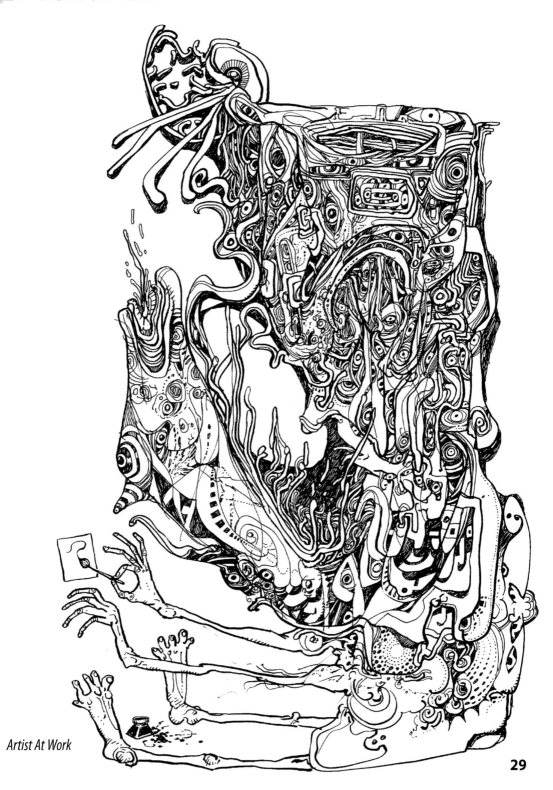

Artist At Work

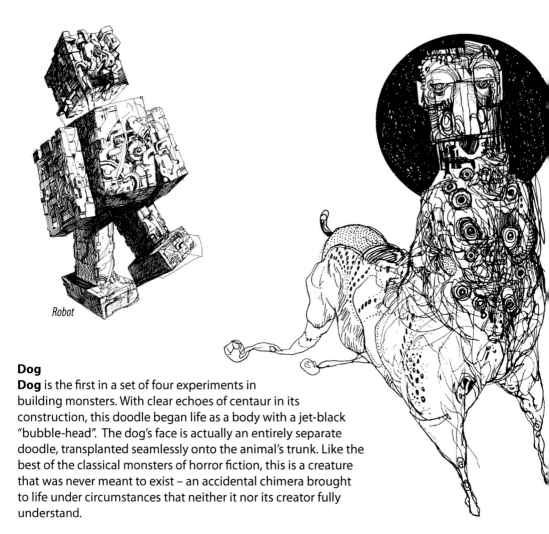

Robot

Dog

Dog is the first in a set of four experiments in building monsters. With clear echoes of centaur in its construction, this doodle began life as a body with a jet-black "bubble-head". The dog's face is actually an entirely separate doodle, transplanted seamlessly onto the animal's trunk. Like the best of the classical monsters of horror fiction, this is a creature that was never meant to exist – an accidental chimera brought to life under circumstances that neither it nor its creator fully understand.

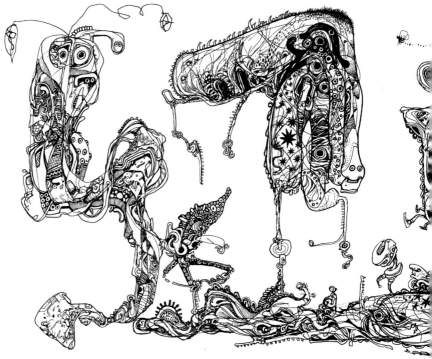

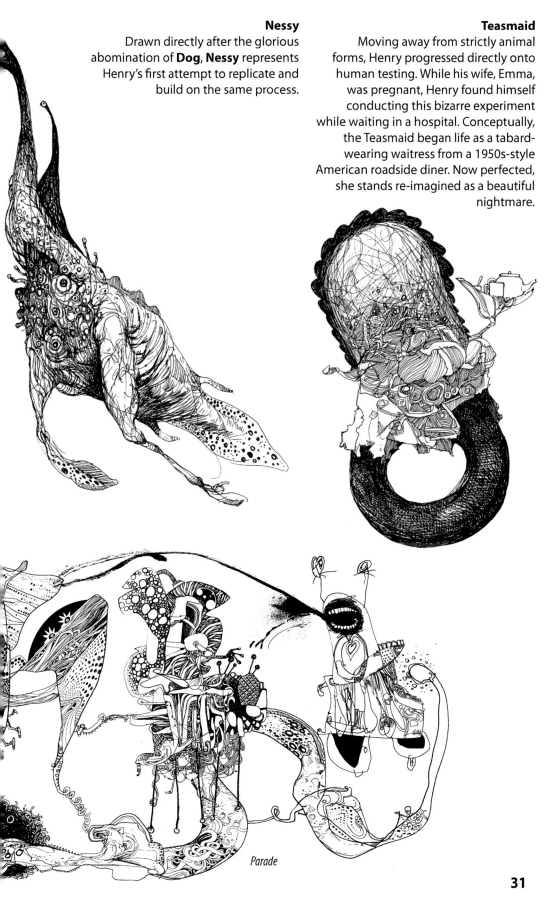

Nessy

Drawn directly after the glorious abomination of **Dog**, **Nessy** represents Henry's first attempt to replicate and build on the same process.

Teasmaid

Moving away from strictly animal forms, Henry progressed directly onto human testing. While his wife, Emma, was pregnant, Henry found himself conducting this bizarre experiment while waiting in a hospital. Conceptually, the Teasmaid began life as a tabard-wearing waitress from a 1950s-style American roadside diner. Now perfected, she stands re-imagined as a beautiful nightmare.

Parade

Demon

A predatory behemoth from the pockets of possibility that exist between passing moments. Demons are an artefact of the way humans perceive the passage of time - and were that passage ever to cease, they would be revealed at last to the world. While time flows freely, the demons remain imprisoned between instants, free to feed only on the discarded flesh of our past selves.

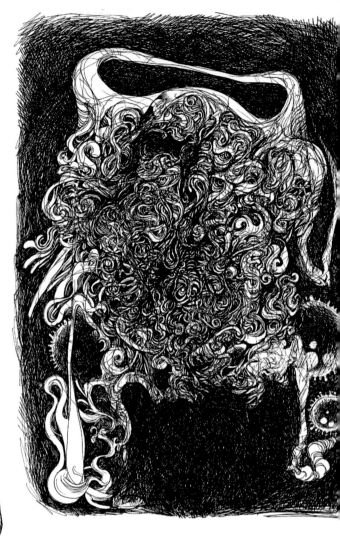

Monster Test

Last specimen in the series of inhumane experiments that began with **Dog**. Once again, Henry uses tiny, helpless human figures to lend a sense of scale and dynamism to the creature. However, by this stage he was finding it increasingly difficult to replicate the accident that sparked this set of images – as if the unforced, unintended nature of Dog had been a key component in the doodle's impact.

Dinosaur
An exercise in surreal, almost stream-of-consciousness doodling. A smartly dressed half-man, half building is struck by a sudden, intriguing thought. He imagines a masked dinosaur, controlled from within by tiny, dancing creatures. The concept is so vast that it bursts out of the half-man, half-building's head. Suddenly, that random thought becomes the whole world's problem.

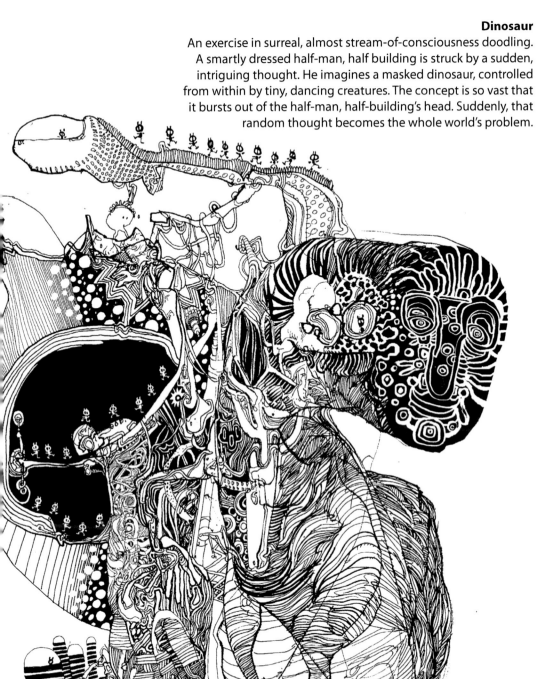

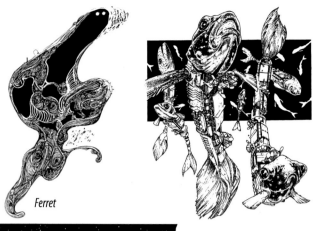

Ferret

Table Tennis Fish

While included in this collection for its thematic and aesthetic relevance, **Table Tennis Fish** is actually a "proto-doodle" - an example of Henry's personal artwork while still studying at college.

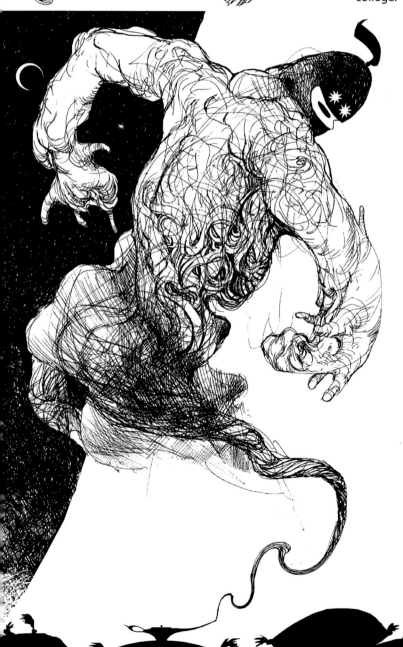

Genie

A frantic scribbling sessi͏ with no pre-defined pur͏ produced a vaporous, ye͏ somehow muscular cen͏ mass. After watching its development for some time, Henry was surprise͏ to discover the torso of ͏ Genie suddenly emergi͏ from the chaos. Final de͏ fully defined the conjure͏ elemental and trapped i͏ the physical form seen h͏

Henry describes the powerful mystical spirit ͏ "an unpredictable kid w͏ social disorder."

Road Thing

hboy

Radishboy in
Gooseberry Forest

Meet the Boss

Management Sh

Henry's mental response to a set of book
office management brought back from a trai
seminar by Emma. The books featured the v
motif of interconnected "information ballc
to represent everything from the flow of
between office departments to the cour
business logic within the human b

With this fascinatingly absurd corpe
language as inspiration, the Management Sl
stumbled blinking into the

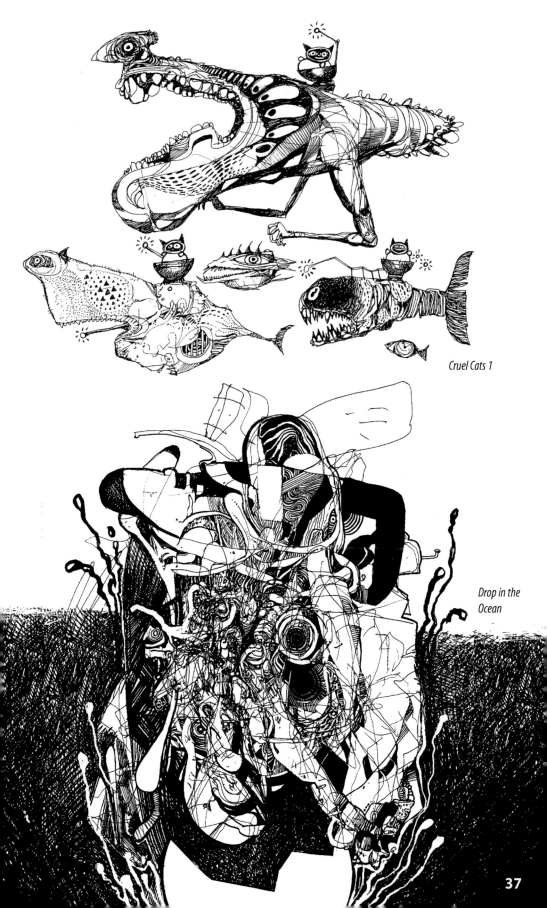

Cruel Cats 1

*Drop in the
Ocean*

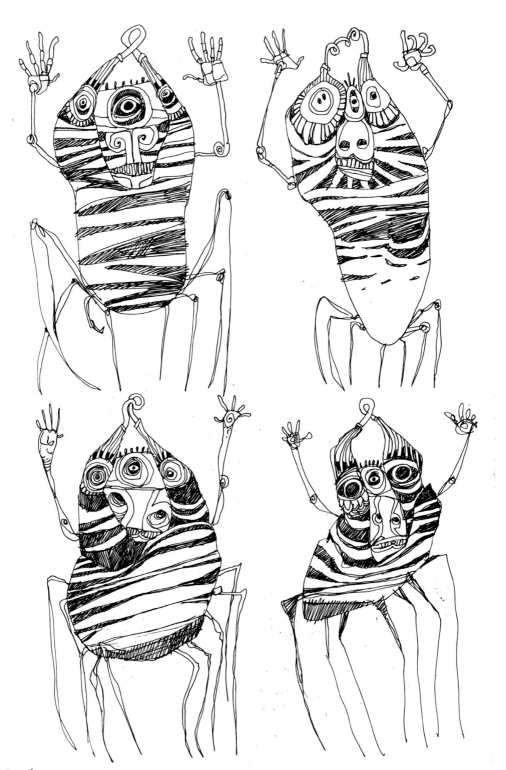

The Beatles

Henry Flint is, by his own admission and any credible standard, an Olympic-class Beatles fanatic. In 60s, he explains, Beatles Fan Club members would send in drawings of the band, rendered to whate standard they were capable of delivering. In homage to both these artistically driven fans and the b that inspired them, Henry presents his own interpretation of the Fab Four.

He leaves identification of the individual members as an exercise for the alert reader.

Chapter Five
Help from Rosalie

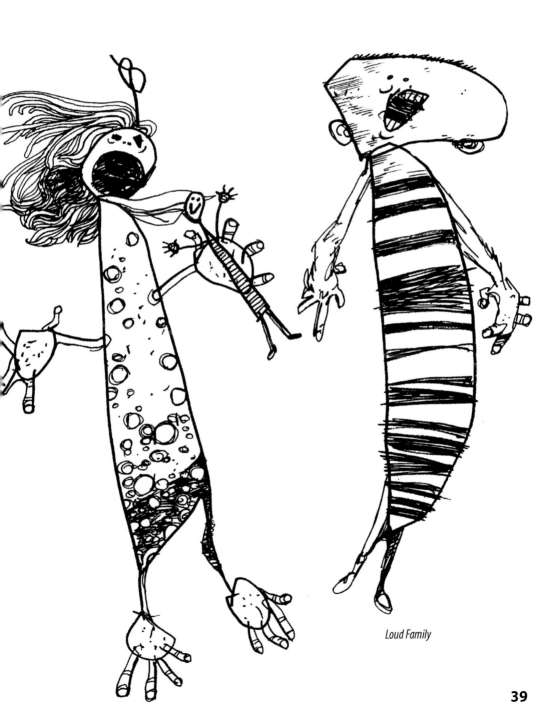

Loud Family

A key element - almost a defining characteristic - of Henry Flint's TV Doodling method is a willingness to relinquish conscious control over the image being created. A TV Doodle is a blindfold drive over rough terrain with one hand on the wheel and the other in the Twilight Zone. When you hit that critical point, when you can step back and watch the image bleed itself onto the page without the aggressively controlling eye so necessary to conventional narrative art, then you've taken the first step.

Step two is to hand the half-completed image and your most indelible pen to a five-year-old child and say, "your turn."

Henry's daughter, Rosalie, took up her father's challenge with the nerve and flair of a true iconoclast. Moreover, she was quickly able to exert full navigational control over the process, dictating subject matter and drawing first blood on every project. All key decisions were left in her fearless hands, from the general direction and level of detail the picture required to the specific amount of stubble that was acceptable on a sunflower's face.

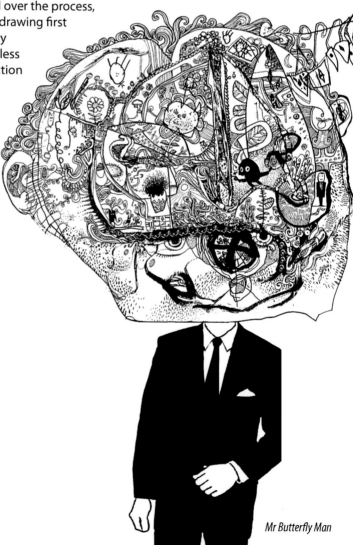

The doodles in this chapter are the results of this blatantly self-destructive trust game - an experiment that was just too Goddamn crazy to fail!

*Cheeky Man
Who Doesn't
Tell the Truth*

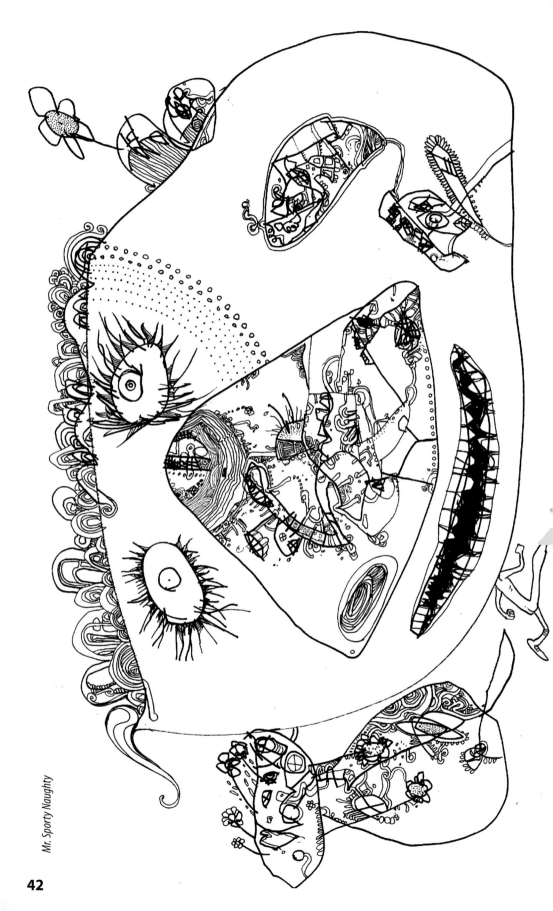

Mr. Sporty Naughty

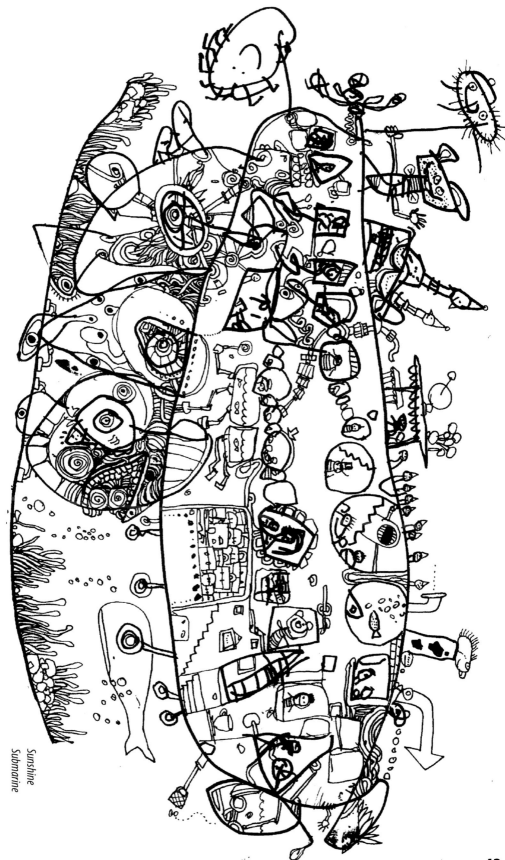

Sunshine
Submarine

43

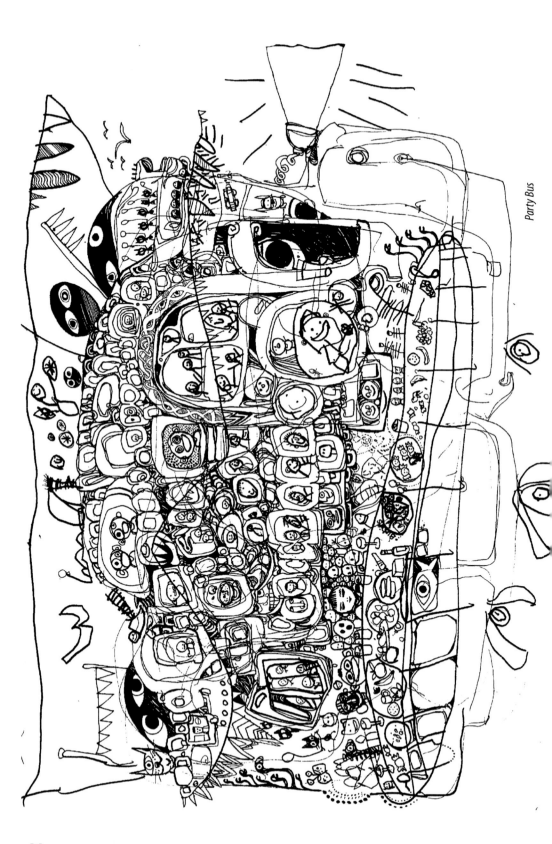

Party Bus

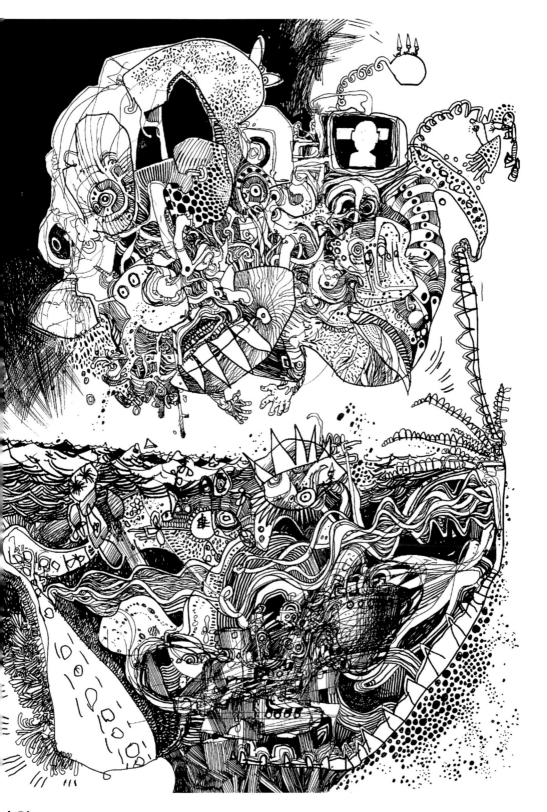

gh Dive

first glance, a viewer might be forgiven for mistaking this image for a terrifying depiction of rror and violence. Henry prefers to see it in more life-affirming terms. The man seen in mid-e has spent the best part of a day summoning up the courage to make this leap. Finally nmitting to the dive, he finds King Neptune himself waiting in the water to greet him.

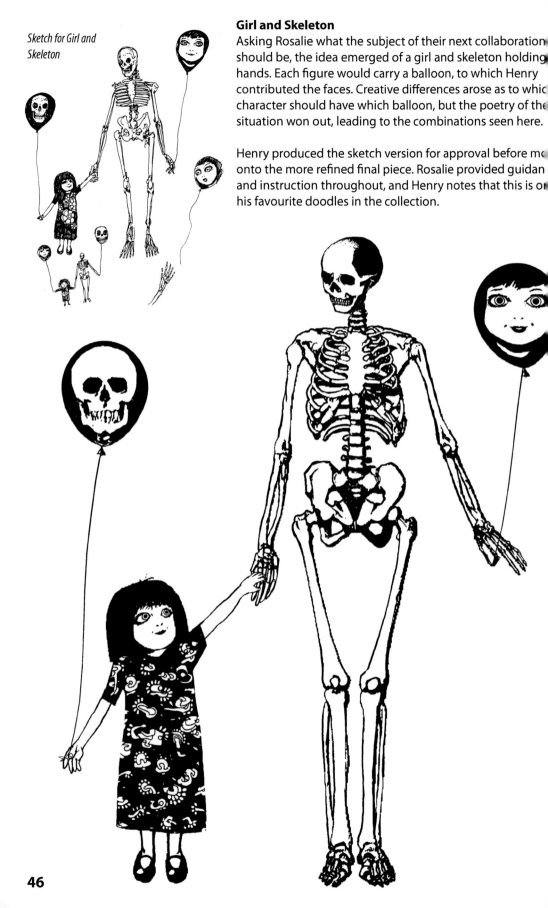

Sketch for Girl and Skeleton

Girl and Skeleton

Asking Rosalie what the subject of their next collaboration should be, the idea emerged of a girl and skeleton holding hands. Each figure would carry a balloon, to which Henry contributed the faces. Creative differences arose as to which character should have which balloon, but the poetry of the situation won out, leading to the combinations seen here.

Henry produced the sketch version for approval before moving onto the more refined final piece. Rosalie provided guidance and instruction throughout, and Henry notes that this is one of his favourite doodles in the collection.

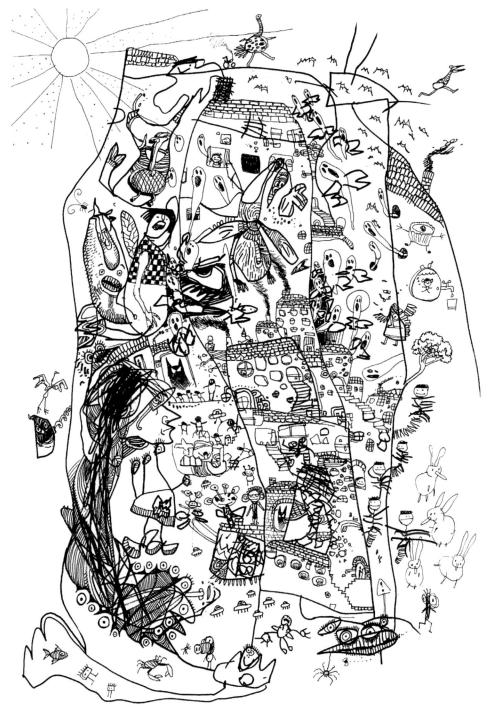

~~H~~aunted House

~~Th~~e twisted little spectacle that came to be called Haunted House began its journey in rather more ~~i~~nocent condition than it ended it. Henry kicked off the experiment with a series of erratic lines ~~in~~tended to evolve into a "building" doodle. Soon after, Rosalie asked if she could join in – her first ~~ar~~tistic gambit being to boldly scribble out everything that had gone before. Undeterred, Henry ~~pr~~essed on with the joint venture, rediscovering the creative rush of what had suddenly become a ~~to~~tally unplanned doodle.

~~Ev~~ents spiralled utterly out of control through the addition of Henry's wife, Emma, to the creative ~~co~~mmittee. The alert viewer will note her lagomorphic contributions at the bottom right of the ~~pi~~cture.

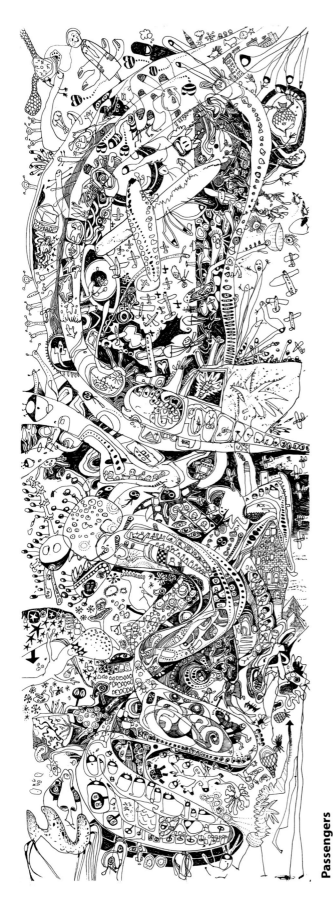

Passengers

The addition of a second artistic hand to the TV Doodling method necessitated a new approach to avoid collisions, entanglements, minor fires and the like. Working on the carpet with an A3 sketchbook, Henry and Rosalie took turns making their various ways around the page in circles, following whatever muse moved them. The result is an incongruously coherent tale of danger and heroism as a transatlantic jet suffers a catastrophic, cascading series of technical failures – the terrified passenger rescued through timely superhuman intervention.

Yes, we know. There is a Beatle at the top left of the piece. Try not to let it worry you.

Chapter Six
Fatal Abstraction

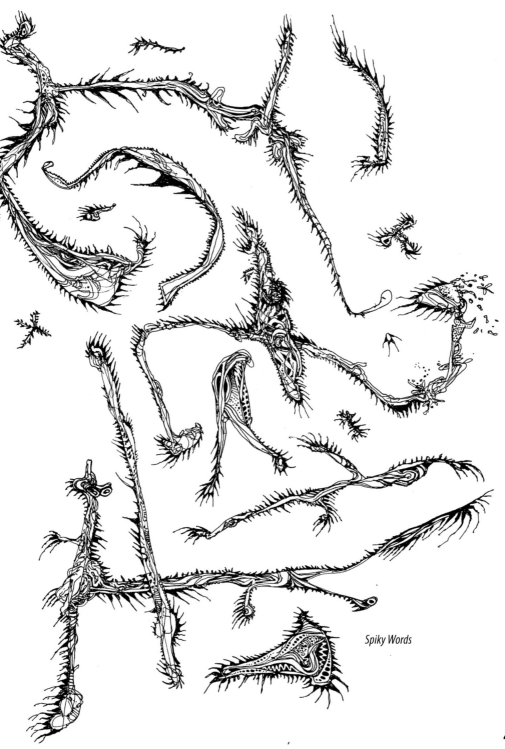

Spiky Words

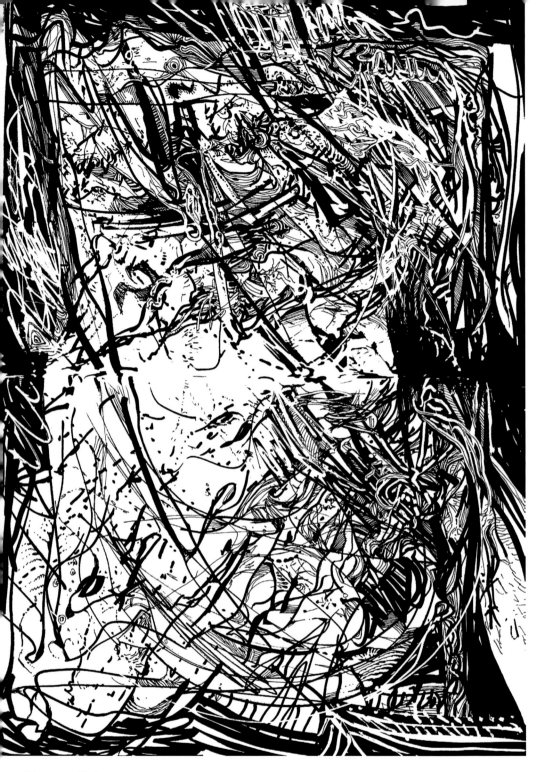

Dinosaur Fight
The work in this chapter represents Henry Flint at his furthest distance from objective reality – images divorced from context, referent and rational explanation, their titles offering only fragmentary insights into the thought processes that inspired them. In many cases, these titles revealed themselves days after the completion of the image. **Dinosaur Fight** is an example of this, its name serving more as a warning of its general chaos than as an anchor for its literal meaning.

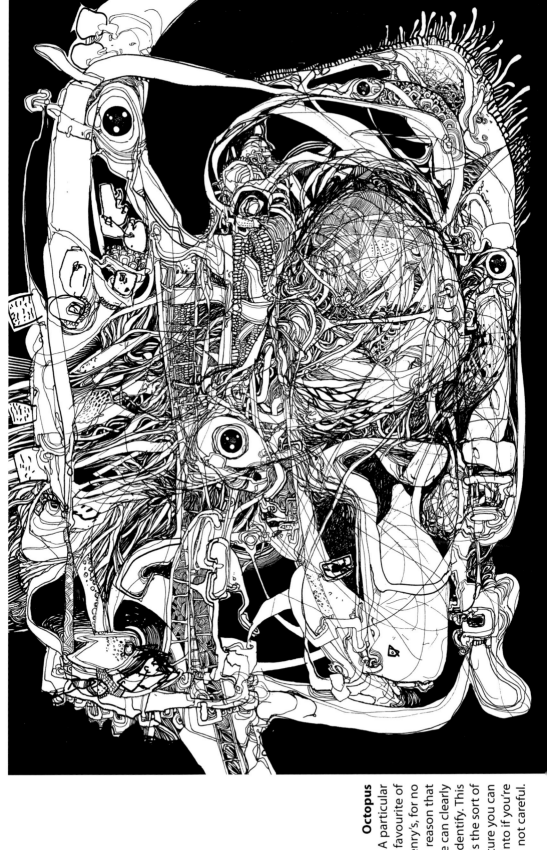

Octopus

A particular favourite of Henry's, for no reason that he can clearly identify. This is the sort of picture you can fall into if you're not careful.

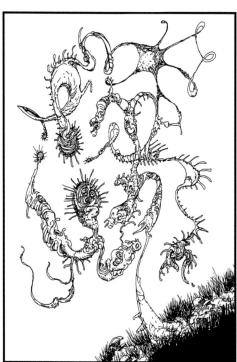

Plant 1 and 2
Two doodles drawn in quick succession while watching, in Henry's words, "a rubbish film."

Henry speculates that, had he paid more attention to it, the film might have seemed less awful – although it could equally be argued that if the film had been better, the doodles it provoked might have been worse.

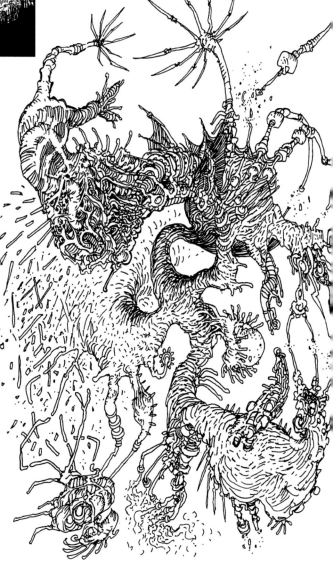

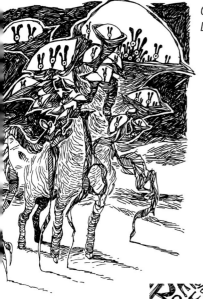

Cyclops Rabbit's Day Trip

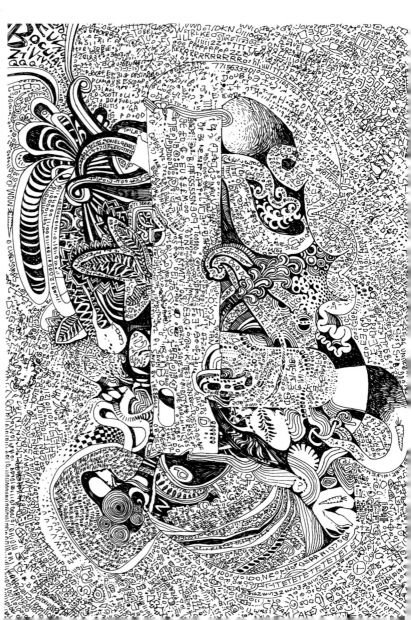

Text

As an acclaimed comics artist, Henry has a sophisticated understanding of the complex relationship between words and images, and the ways in which the distinctions between them are frequently and intentionally blurred. That initial understanding, filtered through the lens of his own dyslexia, gave rise to **Text**.

Henry explains that a page of text and a complicated doodle look virtually indistinguishable to him on the page, and this dizzyingly effective migraine trigger of an image is his interpretation of that experience.

Germ Soup

Another wonderfully rendered psychosis-in-a-bottle, Germ Soup serves as an homage to the work of French painter and sculptor, Jean Dubuffet. Run a Google image search on the name if you ever feel your life has become too simple and manageable.

Onion Soup

Similar in tone and execution to Germ Soup, Henry named this one after the resemblance it suggested to him: "onion soup that's perhaps on the turn."

Ant's Exit

It is commonly accepted among insane entomologists and career fantasists that ants frequently travel at will between dimensions. They are, Henry assures us, the only terrestrial creature with this particular survival adaptation. This image, as much an educational resource as an aesthetic experience, demonstrates the queuing systems used by ants for their return journeys to Earth.

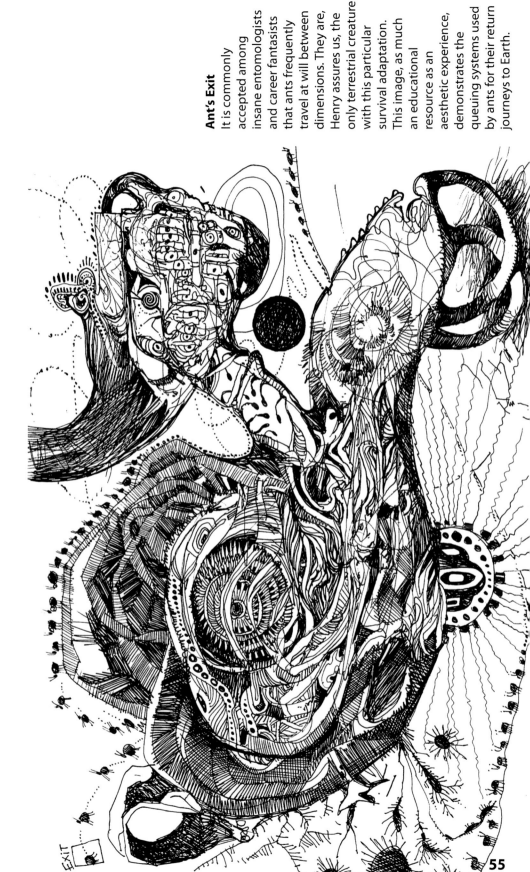

EXIT

Dancer
Dancer is an example of a doodle suggesting its own subject matter.
The central figure was created entirely unintentionally, materialising
unexpectedly when the original orientation of the page was reversed.
The doodle wanted to be a dancer, and so that's what it became.

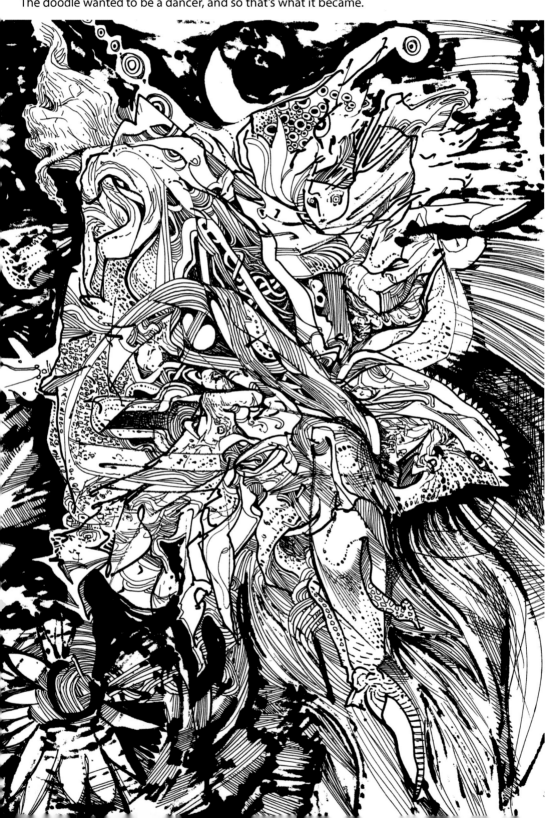

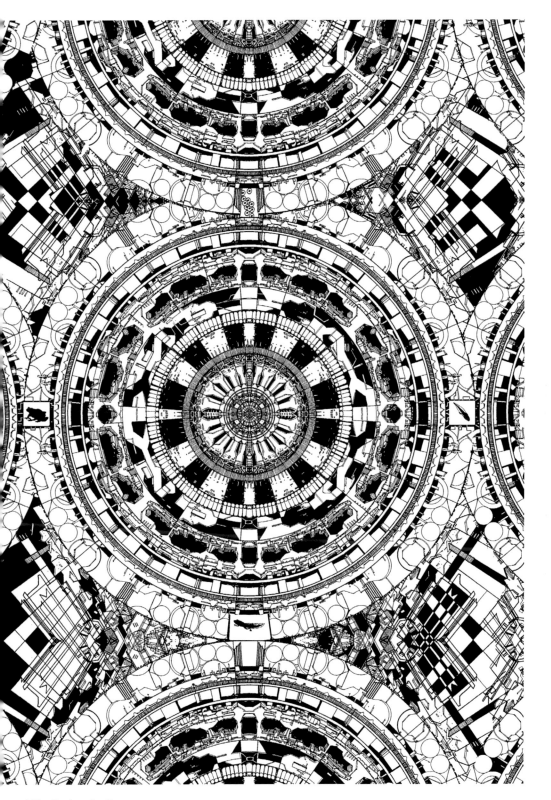

Life Cycle of a Frog
Here we see Henry's interpretation of the diagrams often used in schools to teach
the lifecycles of animals. In this instance, Henry has chosen to focus on the symbolic
mechanisms used to convey this information, rather than the processes they describe.
The wheel motif itself becomes a thing of meticulous beauty, worthy of celebration in
its own right. The frog is reduced to almost incidental status.

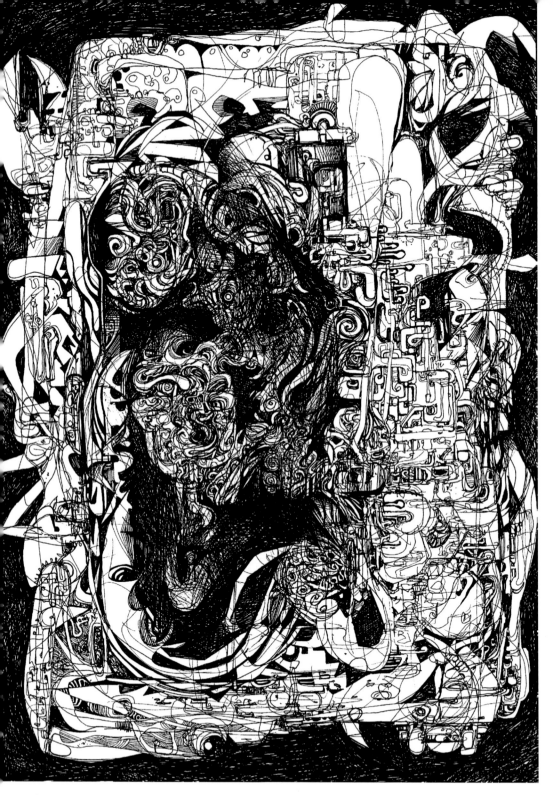

Prisoner

While mapping this doodle out onto the paper, Henry gradually became aware that he was building a prison. Someone - or something - got trapped inside the image and to this day Henry is uncertain what it is. More to the point, Henry believes that even it doesn't know what it is – nor what the consequences of its release might be.

A Choice Between Two Wrongs

An art book might strike the reader as a curious choice of venue for the confession of an iniquitous past. However, around a quarter of a century ago, Henry lived another life as a criminal mastermind, employing extra-legal methodology in his acquisition of Fighting Fantasy gamebooks. For the tragically uninitiated, these books were a form of interactive fiction where dice rolls and decisions made by the reader actively directed the flow of the narrative.

While Henry has fully reformed, he still recalls the stark, life-and-sudden-fatal-impalement choices offered by these beautifully illustrated, wonderfully childhood-destroying books. This collage of discarded ink smudges lay unused for months until a fresh perspective revealed two unmarked cave entrances...

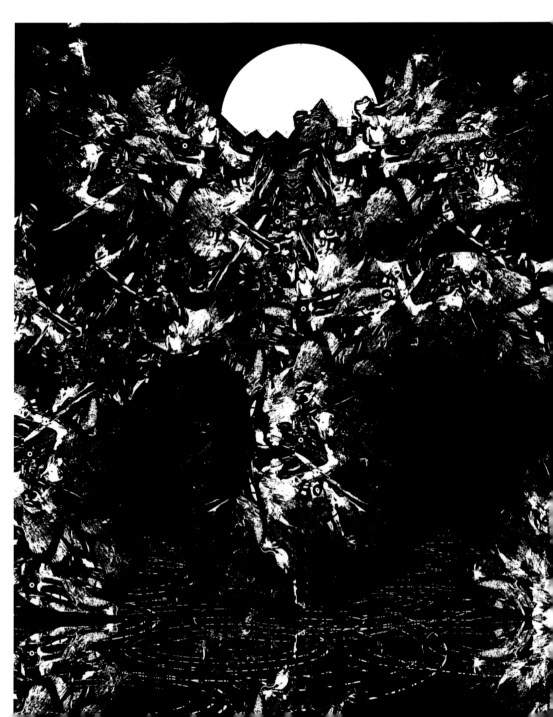

Pylon's Thought Balloons

Henry's wife has a distinct phobia of electricity pylons. This doodle was purpose-designed as part o
ongoing therapy or, as Henry himself puts it, "to mess with her mind."

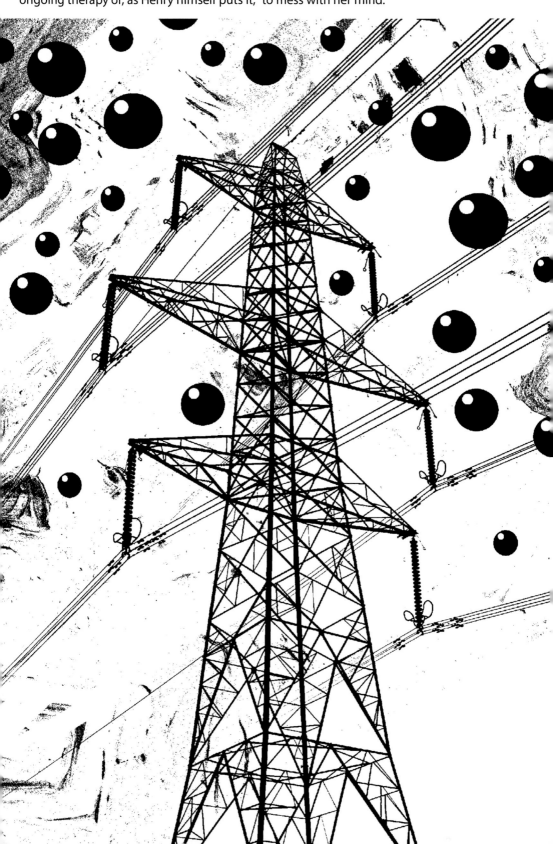

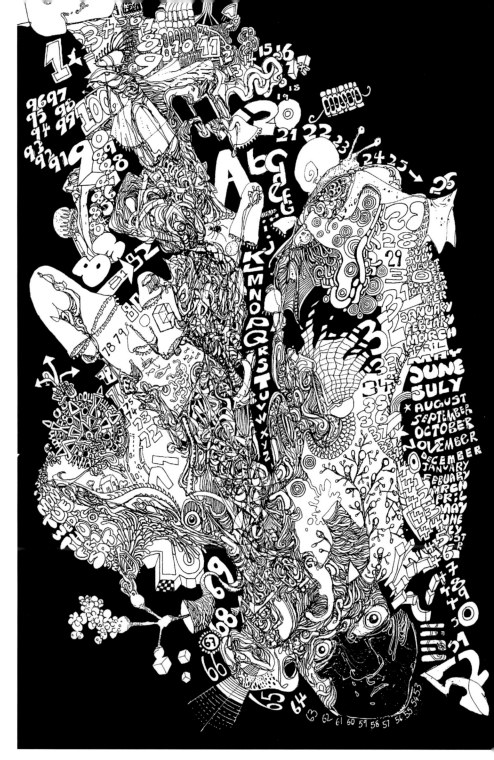

One to One Hundred

This image stems from a time when Henry still clung to certain preconceptions about what a TV Doodle should be. Henry rarely incorporates text into his artwork, having scratched that particular creative itch at college by filling entire sketchbooks with, as he describes it, "all kinds of pretentious stuff." These days he avoids declarative statements in general in his work, as a means of future-proofing it against his own critical eye. One to One Hundred, for example, presents the words purely as images in their own right,

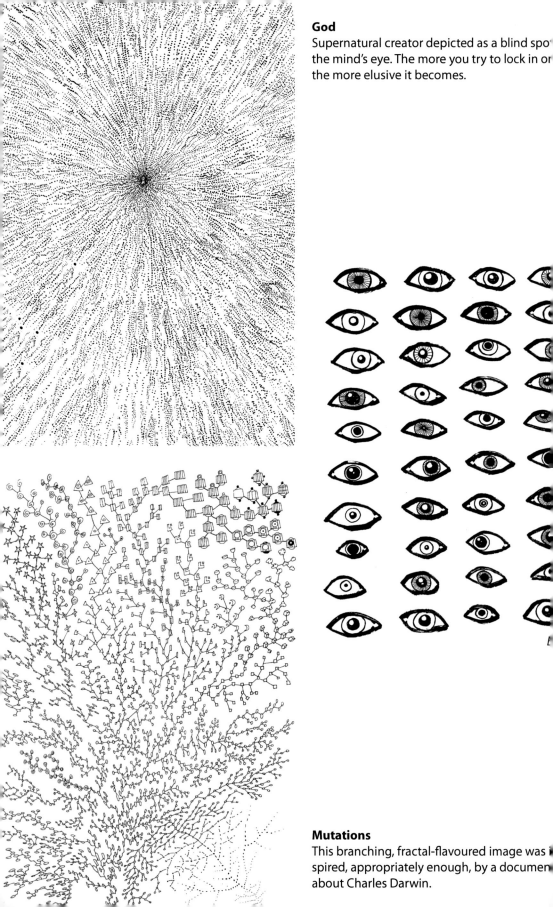

God

Supernatural creator depicted as a blind spot in the mind's eye. The more you try to lock in on it, the more elusive it becomes.

Mutations

This branching, fractal-flavoured image was inspired, appropriately enough, by a documentary about Charles Darwin.

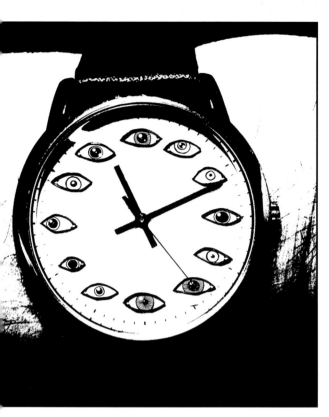

Watch

A visual pun on the word "watch", the wristwatch staring impassively back at its wearer. Henry imagines that each eye would blink in turn as the second hand sweeps past it.

67000

A perfect example of a sign divorced from the information it signifies. Henry heard the number that provides this doodle's title in a radio programme at the height of the credit crunch. Assuming the figure to be important, he wrote it down on the back of an envelope and went on with his life.

The next day, Henry drew an eye rising like the sun over a rural landscape in black marker. By this time he had completely forgotten what the figure of 67000 had referred to, and why it had seemed important. The number became emblematic for the surreal, contextless image, and ultimately provided its title.

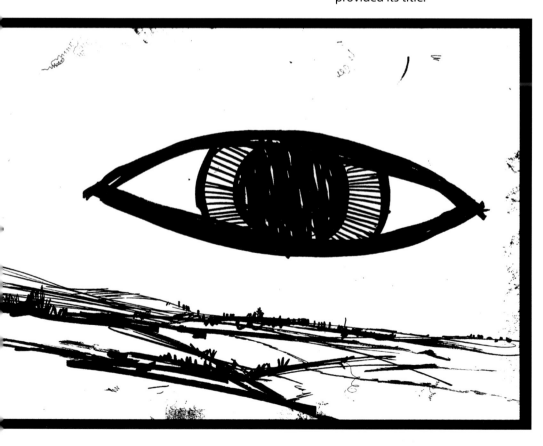

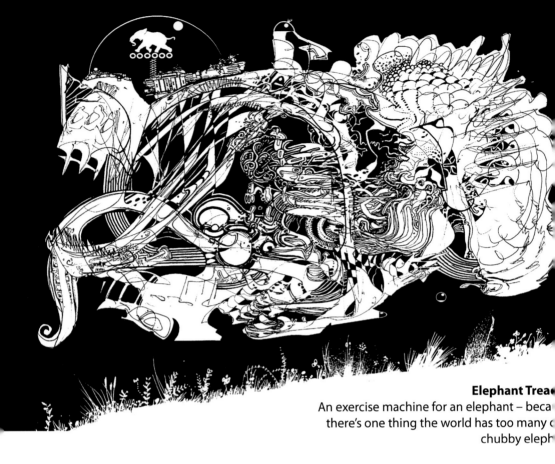

Elephant Trea[d]
An exercise machine for an elephant – beca[use]
there's one thing the world has too many [of]
chubby eleph[ants]

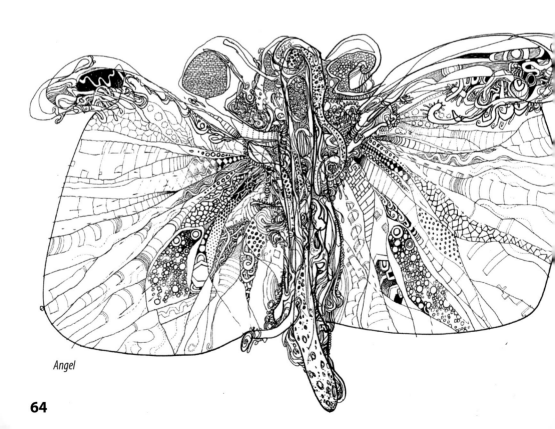

Angel

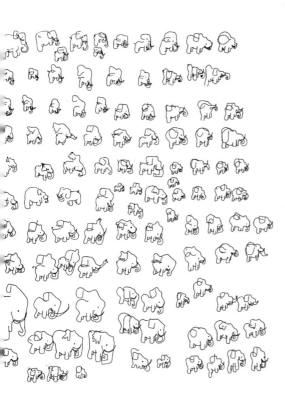

Blind Elephants 1 and 2

More a scorecard for a game than a drawing, the object of the exercise is to draw a succession of elephants with your eyes closed. Henry offers the following guidelines and advice:

To draw the elephant, the line starts with the ear then stops for the tusk and eye. Then add a few "start stop" lines for the body. You need to be quick as you can otherwise lose the sense of where things are. Always look at the last finished elephant before starting the next.

Henry particularly recommends this TV Doodling exercise for programmes that require more visual attention.

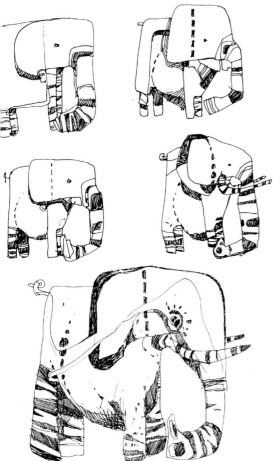

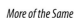

More of the Same

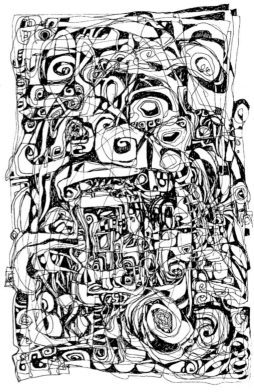

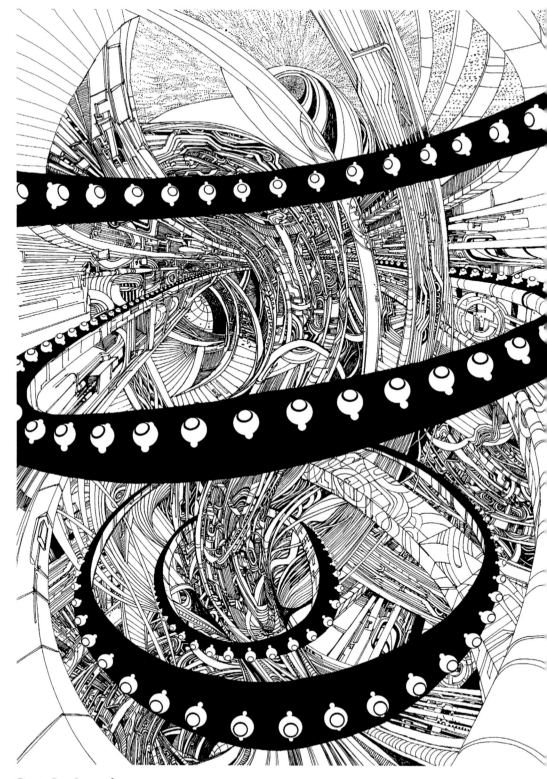

Beats Per Second
This is the only piece of commissioned artwork in this collection, created for DJ Food. It is included as it follows the basic doodling philosophy described in the book - and even if it didn't it's just too cool to leave out. As with the other doodles, it was begun with little or no idea as to the intended e result. Once the basic form had revealed itself, the little robots were added in Photoshop, giving the piece a rhythmic, almost musical feel perfectly suited to the CD it was created for.

Explosion

As much an exercise in destroying a pen as creating an image – and successful on both counts. Henry recalls having a great deal of fun mashing felt-tip against paper on is piece. He describes it as a snap-ot taken in the instant before the exploding object is obliterated.

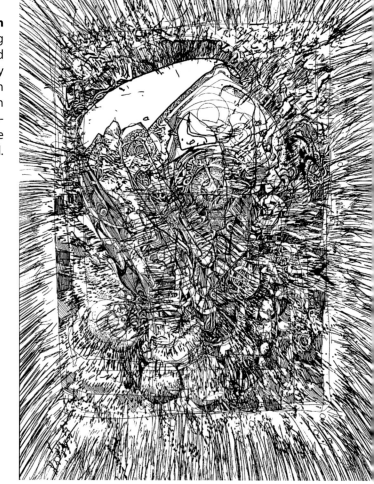

partacus

e doodle. While its title was red by the film Henry was ning while he created it, he is at s to explain how his brain and derived one from the other. In y ways, this is TV Doodling in its sed form.

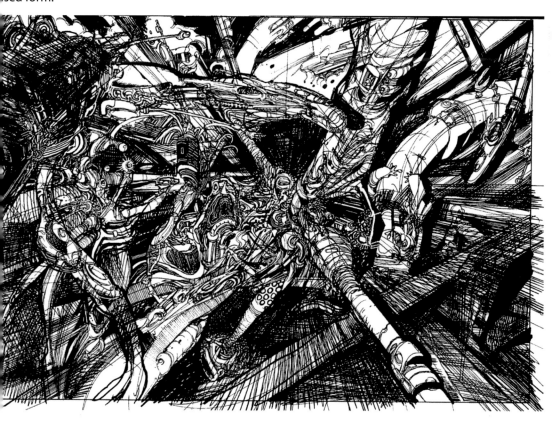

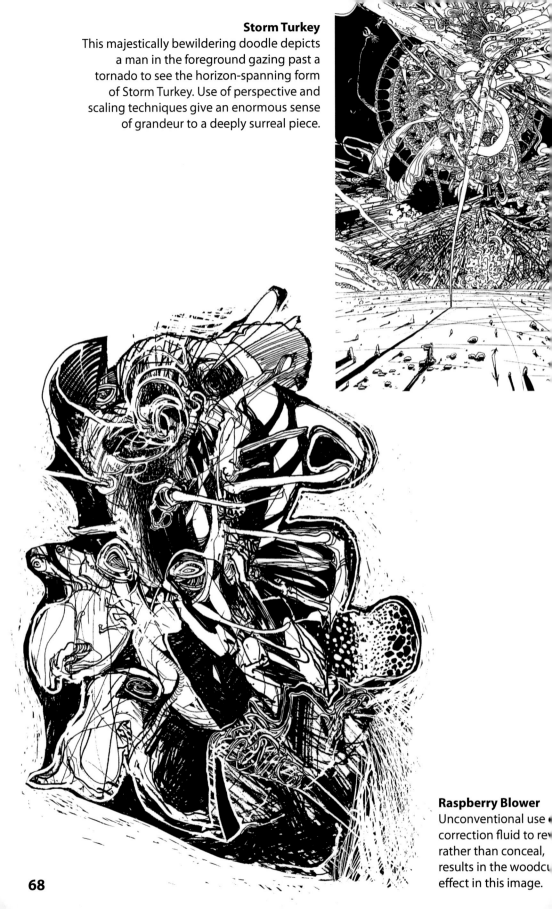

Storm Turkey
This majestically bewildering doodle depicts a man in the foreground gazing past a tornado to see the horizon-spanning form of Storm Turkey. Use of perspective and scaling techniques give an enormous sense of grandeur to a deeply surreal piece.

Raspberry Blower
Unconventional use o
correction fluid to rev
rather than conceal,
results in the woodcu
effect in this image.

Fish
Bold, swirling tangles of linework lend a tremendous sense of frenzied motion to this image of salmon swimming upstream.

Violin

A towering collage of colliding images, Henry describes the central conflict of Violin as involving a man idly feeding the ducks at his feet while a girl calls for him to look at the stars instead.

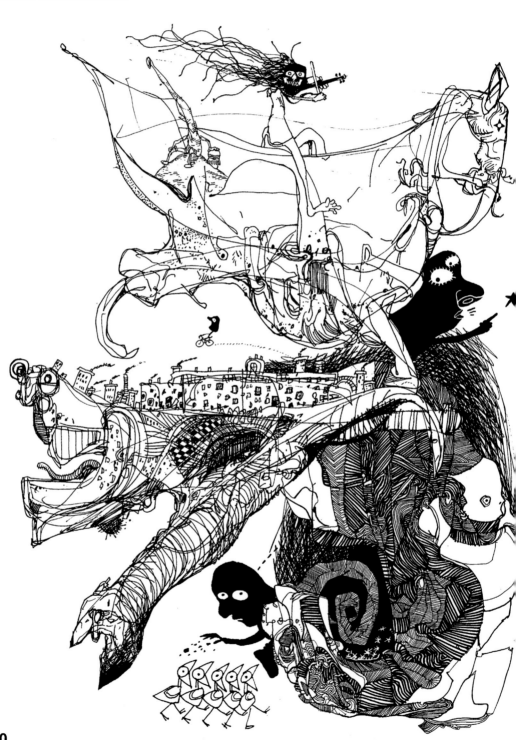

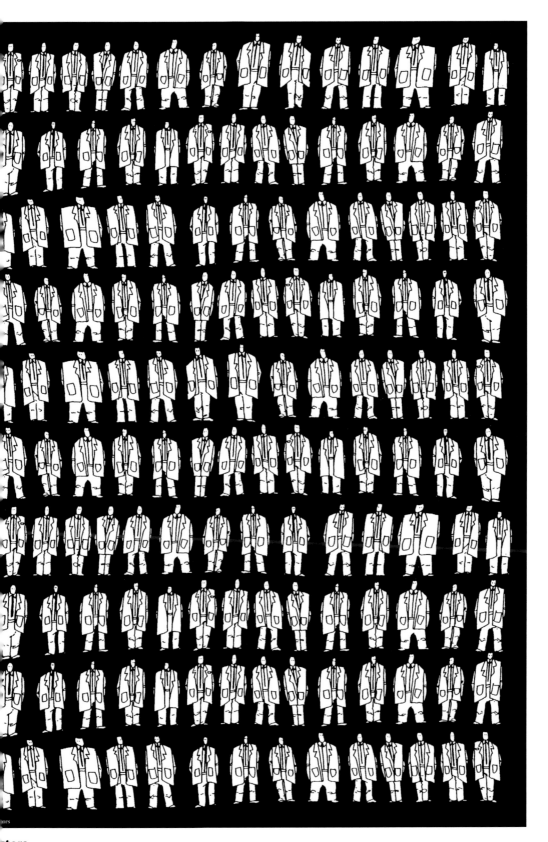

...ctors

...ry spent a night in a hospital, on a relatively trivial matter.
...parently, there were bloody doctors everywhere!

Spaghetti

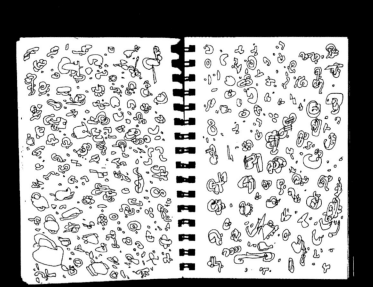

Chapter Seven
In Which Henry Tames a Sketchbook

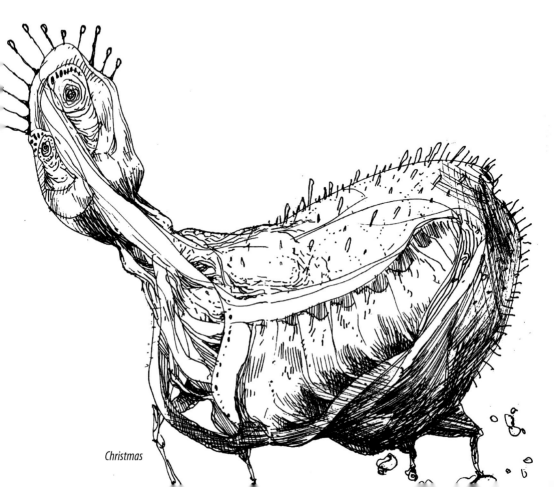

Christmas

Henry Flint is an insatiable, implacable collector and consumer of sketchbooks. As anyone familiar with his work will appreciate, there simply aren't enough blank pages in the world to cope with the overspill of his imagination.

The sketchbook Henry refers to as "Zobe" (and not all his books are honoured with a name) is a small moleskin-bound roadmap of weirdness, chaos and dangerous beauty. The Flint sketching method applied to it was to limit himself to a maximum of ten minutes per page and to fill the book as quickly and remorselessly as possible.

Spending too long over a sketch can be fatal, as it can lead to entire books being abandoned after the first page because the artist can't bring himself to draw on the second for fear of the ink bleeding through and destroying the pre-existing masterpiece. As Henry himself points out, it's far wiser to tackle a new sketchbook the way one would attempt to ride a wild bull – with speed, tenacity and a high probability of failure or injury.

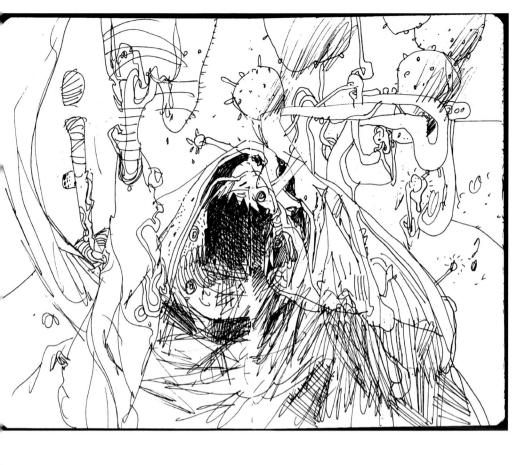

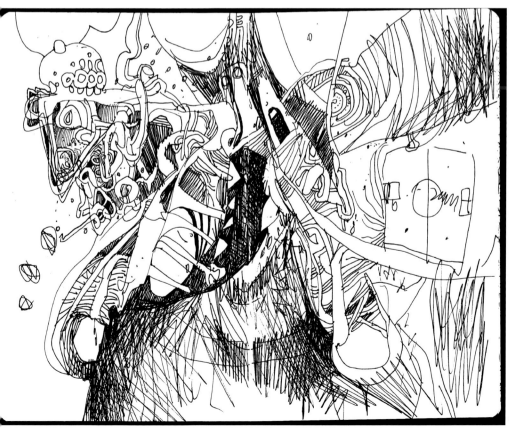

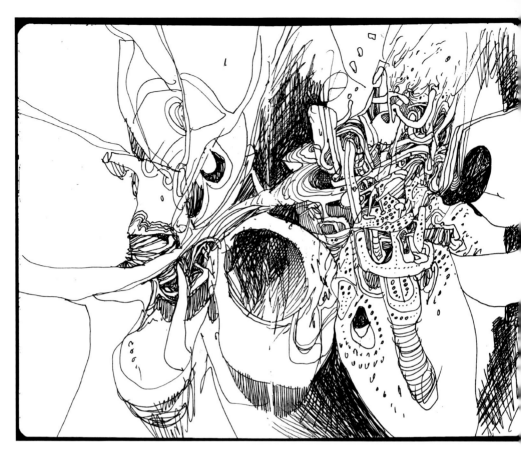

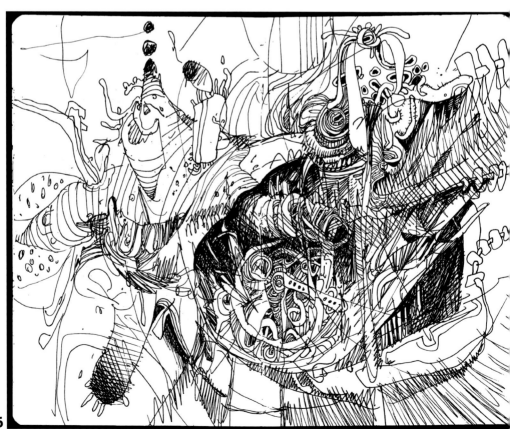

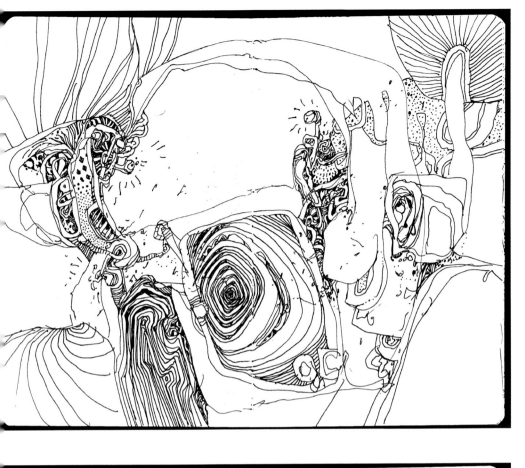

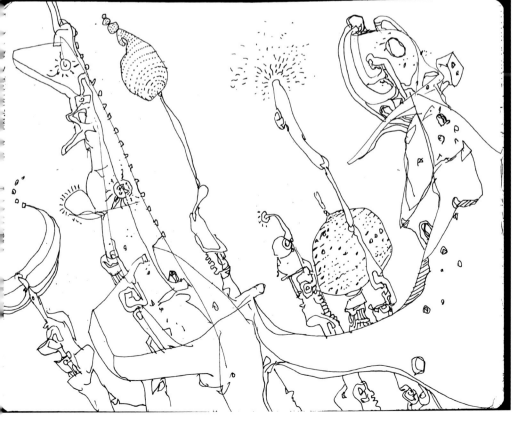

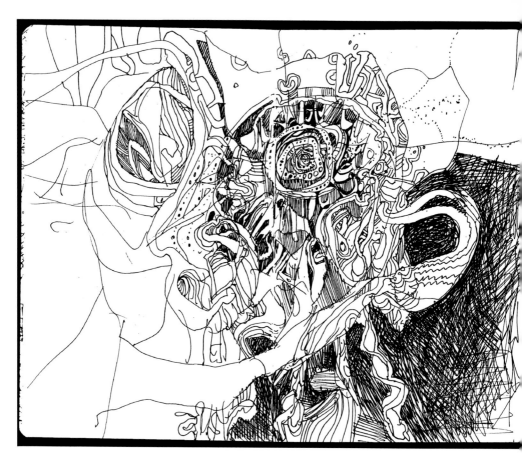

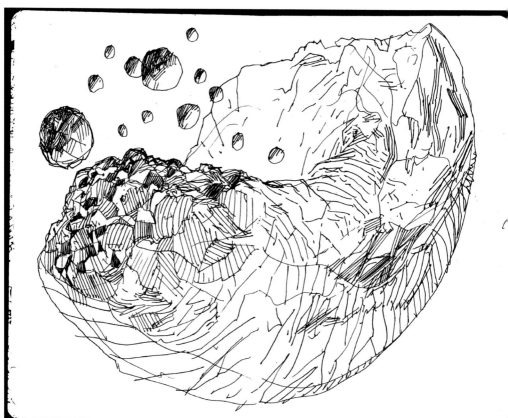

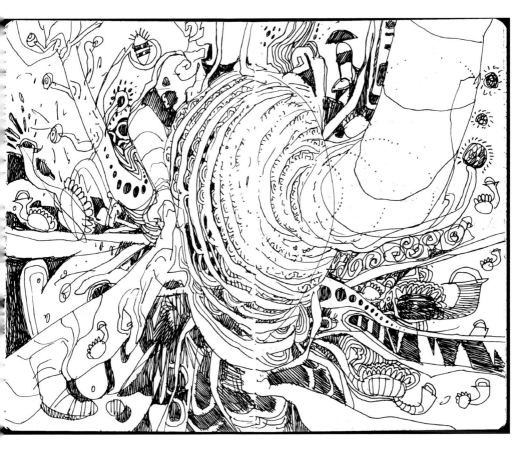
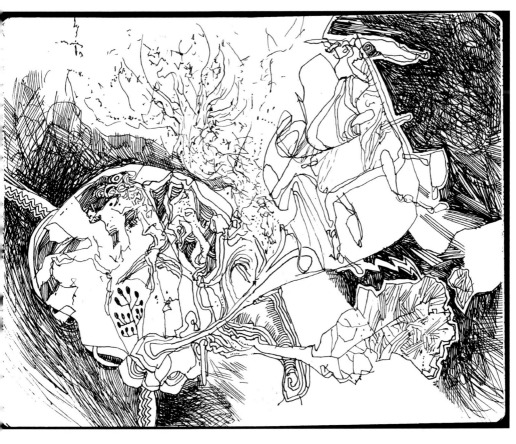

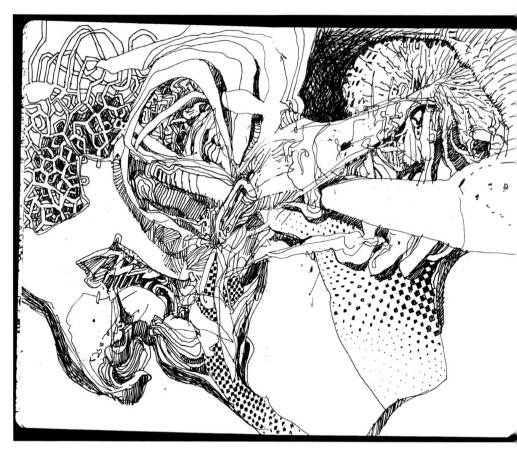

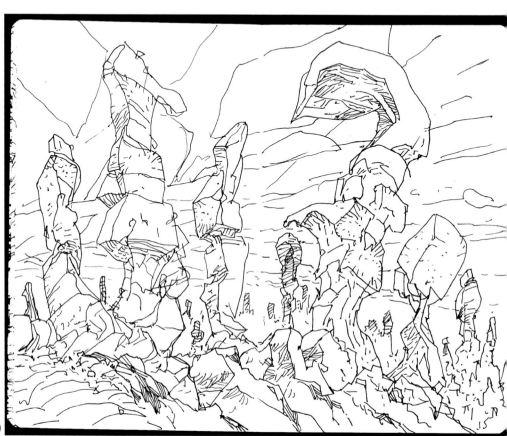

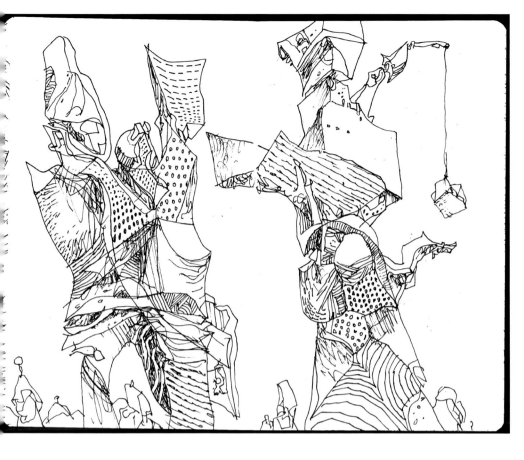

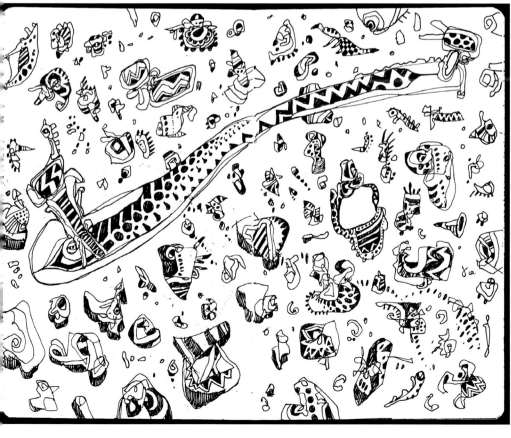

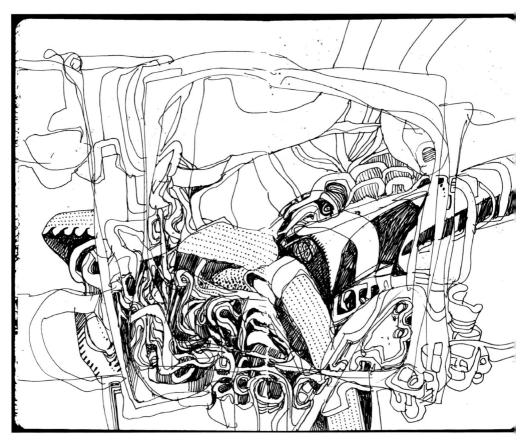

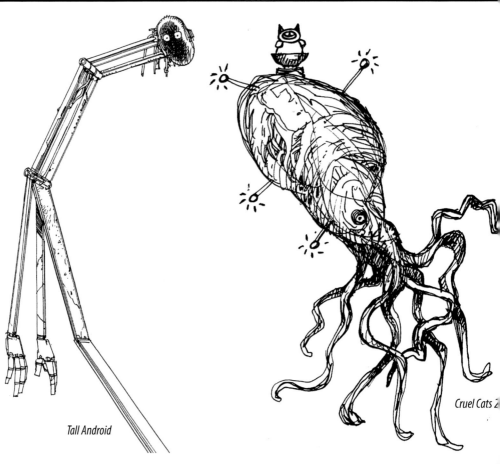

Tall Android

Cruel Cats 2

Chapter Eight
The Many Faces of Henry Flint

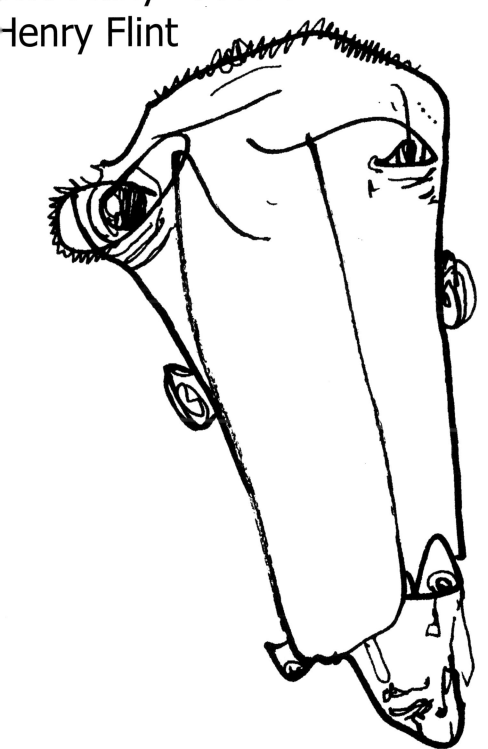

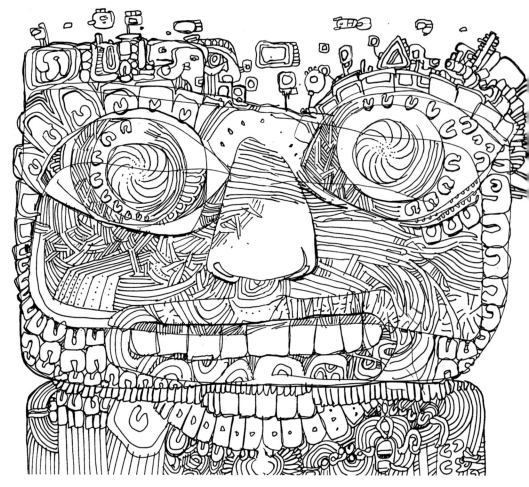

Aztec Face

Created while Henry was watchir
a documentary about Aztec histc
Wild and hypnotic, this doodle
displays its influences fiercely wit
every line on the page.

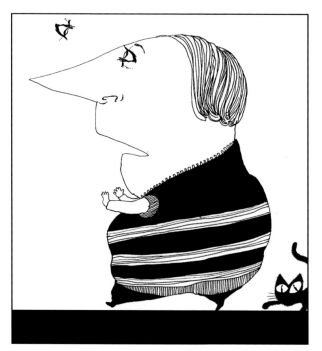

Lady and the Eye

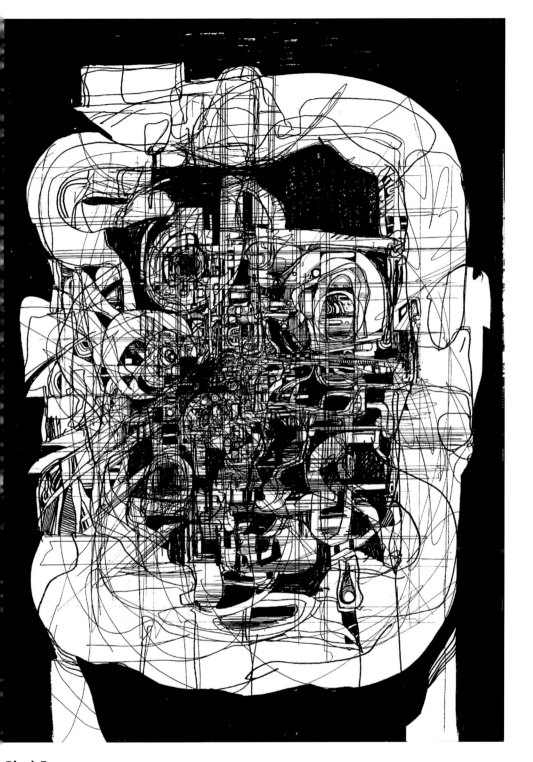

Blank Face

Henry describes this doodle as an interpretation of the blank expression that occasionally sweeps over a conversational partner's face when struck by a sudden, utterly absorbing thought. Unable to disconnect from its enormity, the mind-blown victim's consciousness spirals in on itself, lost in the maze of its own thinking.

It is perhaps reasonable to assume that this is a phenomenon that Henry provokes in people on a fairly regular basis.

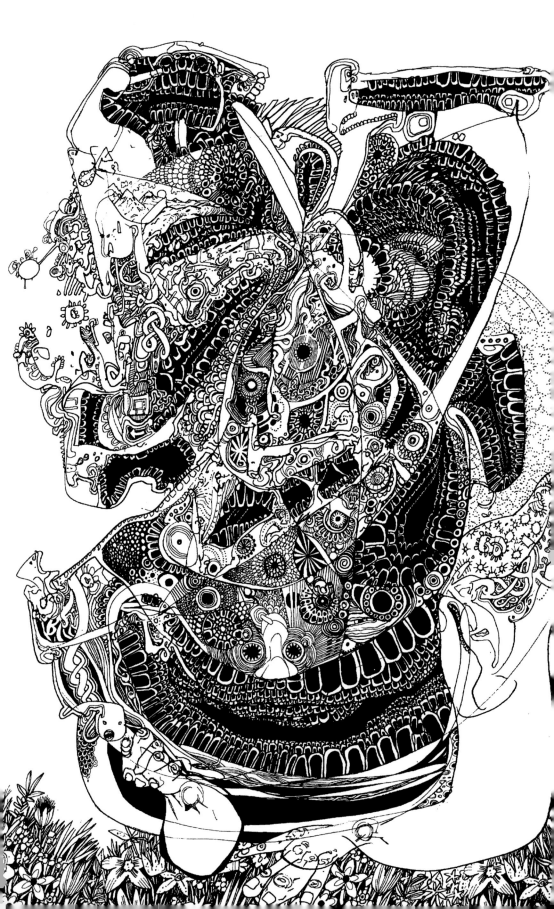

opposite

rk of terrifying detail,
second of study
ling some fresh
r. As an experiment,
y challenges the
r to locate the
ure's true eyes.

People Teeth, Maze Chin

Henry centres his explanation of this doodle on the topics of business and banking. Tiny, anonymous figures are caught within a much larger, more complex system, fulfilling their pre-defined and inescapable roles in a process they cannot hope to understand or influence. Tellingly, the maze itself is unsolvable. There is literally no way out.

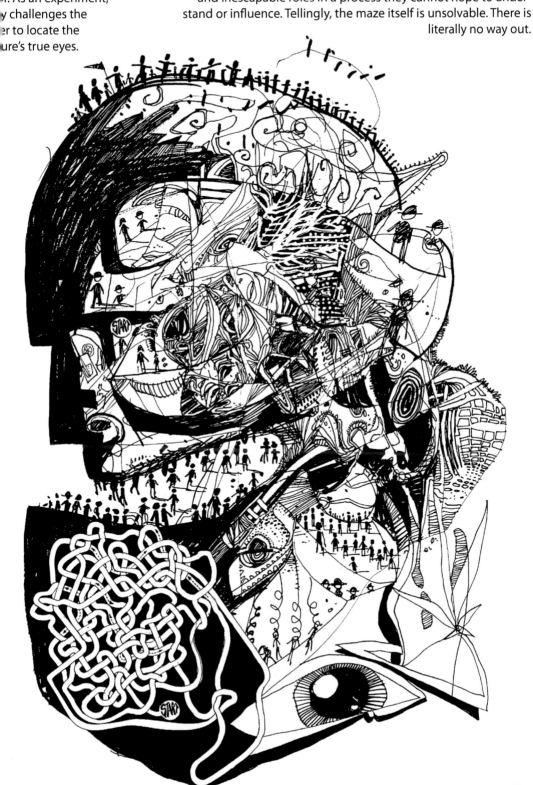

The Spanner and the Space Suit

Henry conceived this piece as an experiment in pushing comic layout past its elastic limit and into strange new territory. By the benchmarks of conventional single-narrative clarity, he judges it to be a deliberate and dramatic failure. However, from a broader perspective, the naked weirdness of this segmented, meticulously mutilated art-spasm tells a hundred stories on a single page. The Spanner the Space Suit was picked out for use as a CD single cover for DJ Food.

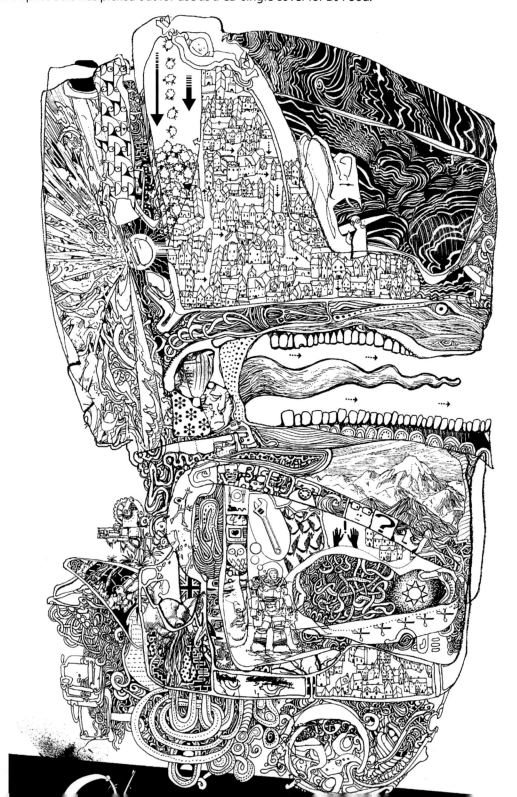

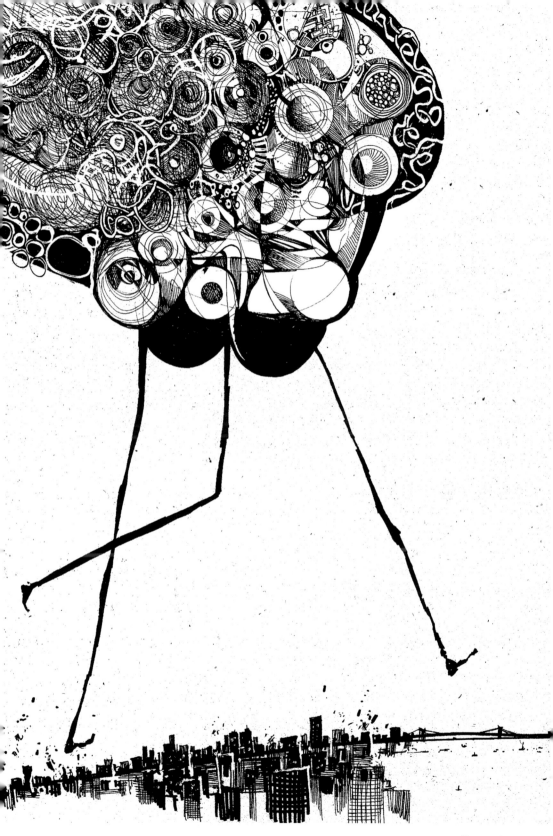

Not again?

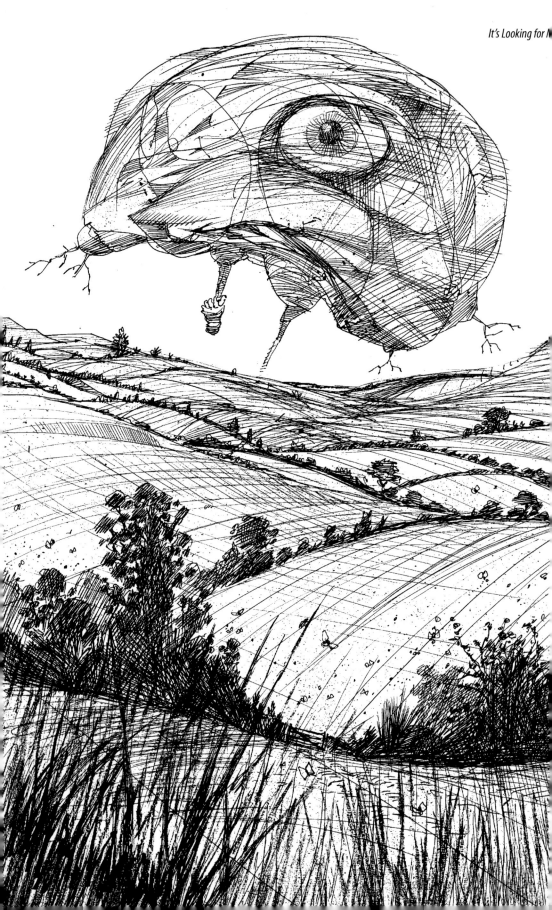

Not again?
It's Looking for Me
Hide from the Monster

These three potent, invasive images belong together in sequence – their shared theme developing through them, each building on the one before. With each successive image, the viewer is increasingly placed in a position of personal victimisation, singled out by monstrous, alien aggressors.

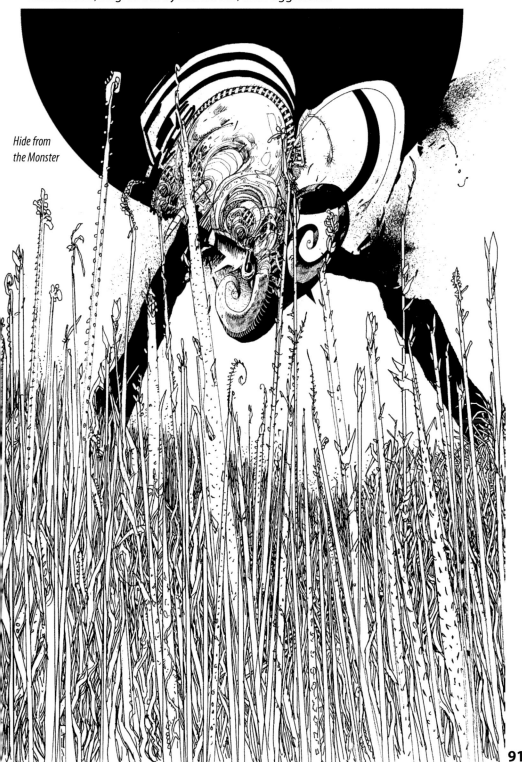

Hide from the Monster

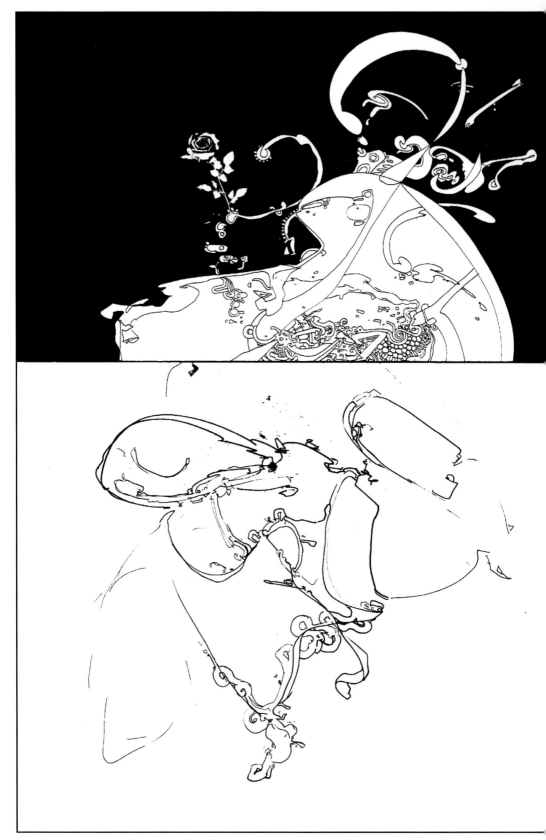

Chapter Nine
Manifesto of Madness: Hints and Tips from Henry Flint

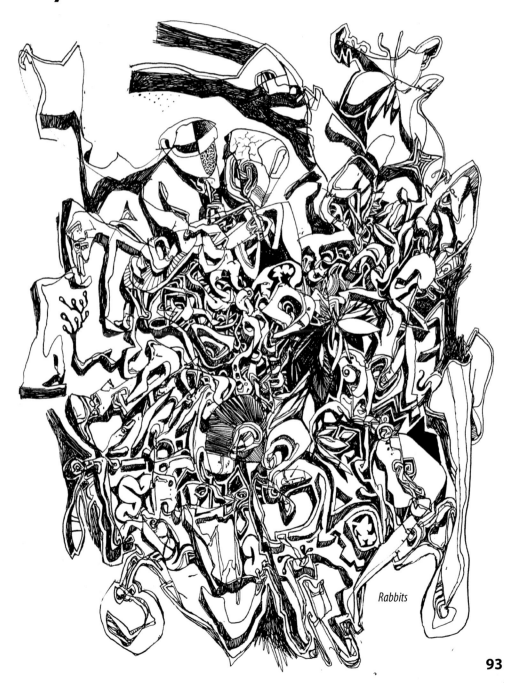

Rabbits

1. The most important rule: break all rules but this one.

2. Pencil is the weapon of the weak. Pencils encourage you to see flashes of brilliant potential as simple, correctable "mistakes". Ink is the lifeblood of the TV Doodle.

3. Recommended tools are gel pens, felt tips and heavy markers. Used sparingly, 0.25 Rotring pens offer scratchy, nervous lines for essential detail. Choose the wrong tool for the job and use it without regret. Correction pens and fluids can do more than destroy. Consider the possibilities of white dots and lines.

4. Embrace the random beauty of the squiggle. Allow yourself up to a minute to squiggle fast, erratic, anarchic lines at the beginning of a doodle. Felt tips are good for this, as the line is constant and fast. Identify an area of the squiggle that appeals to you and work on it. Allow time for your doodle to "click." Try holding the felt tip at the 'wrong end' between thumb and finger. Alternatively, use your non-dominant hand or even close your eyes. Exploit the "mistakes" offered by imperfect control of the pen to create something bold and unexpected.

5. Change the orientation of the page to locate camouflaged animals, faces and objects. Bring these hidden opportunities to life.

6. Don't wait for fickle inspiration. Challenge the tyranny of the blank page. Draw circles, spatter paint and use printed textures. Demolish the white space with newsprint, photos and collage.

7. Perfection is a myth. Don't waste time chasing it. There is no such thing as "getting it right."

8. Welcome frustration. TV Doodling is as confounding as it is relaxing. Frustration is the doodle's way of telling you that you're thinking too hard. Listen to it. Perhaps you're trying to force someone else's style into your art. Your doodling style is your artistic fingerprint. Embrace your inner naivety.

9. Never begin a doodle with the intention of finishing it. You'll chase it forever and never reach your goal. Let the doodle reveal itself on the page. Get inside it on an unconscious level, unraveling the crossed lines, squiggles, smudges and shapes in sync with your own thought processes.

10. Switch on the TV. Switch off the conscious connection between brain and hand. Find the signal and tune it in.

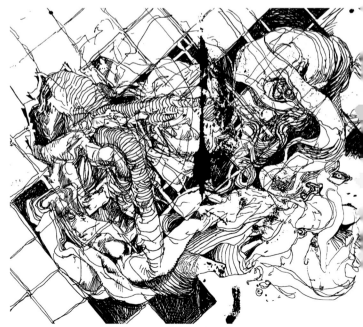

Holiday Homes
From Hell

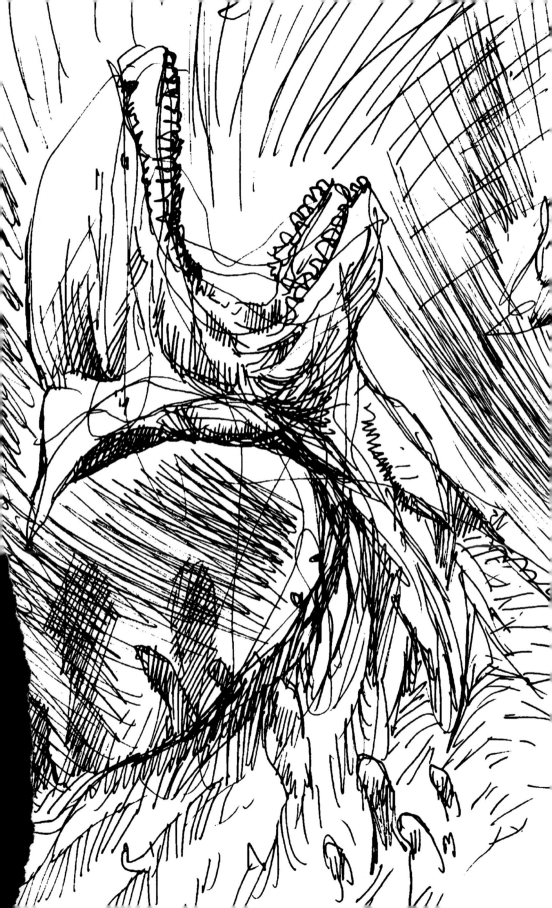

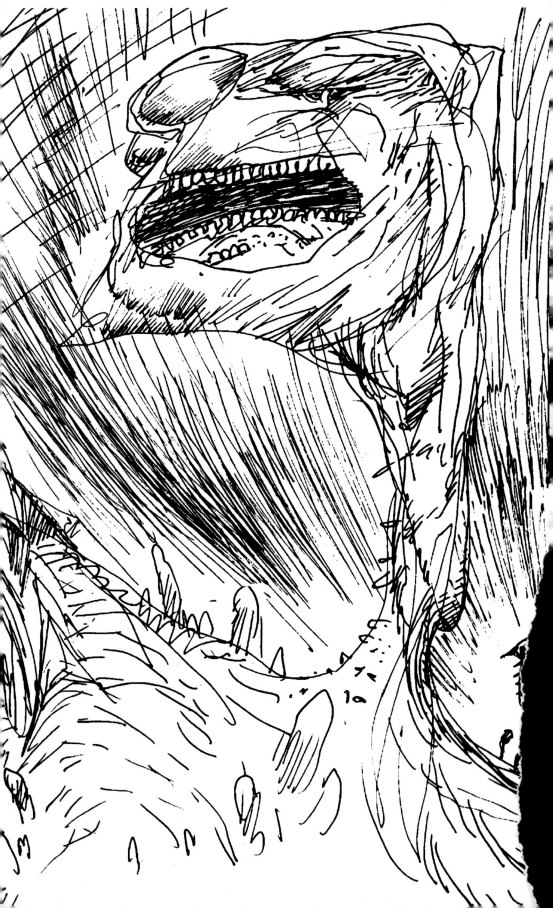